DUFY

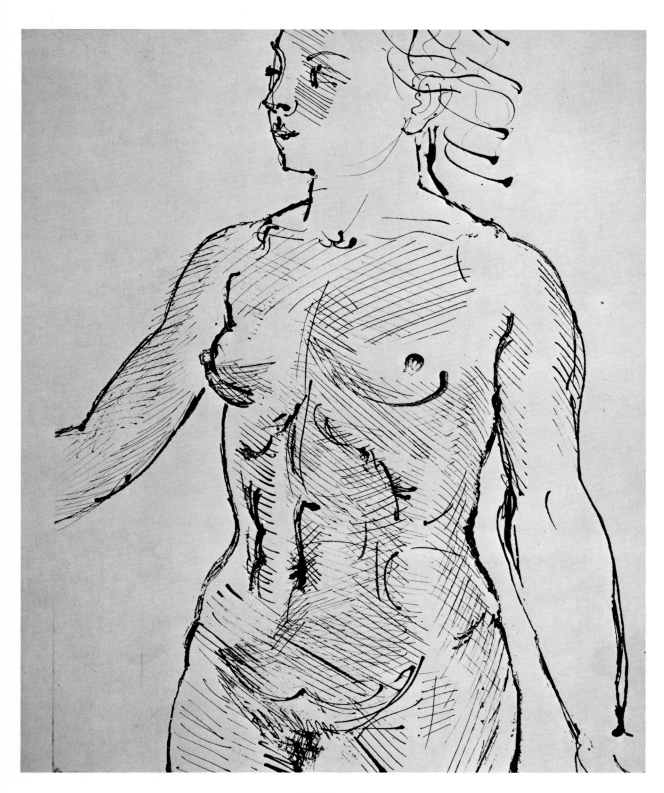

NUDE, 1936

RAOUL

DUFY

TEXT BY

ALFRED WERNER

THAMES AND HUDSON

First published in Great Britain in 1987
by Thames and Hudson Ltd, London

This is a concise edition of Alfred Werner's *Dufy*,
originally published in 1973

Picture reproduction rights reserved by S.P.A.D.E.M, Paris

Printed and bound in Japan

CONTENTS

The beautiful is the promise of happiness.

—STENDHAL

When Henri Matisse, old and bed-ridden but in full possession of his mental faculties, learned of Raoul Dufy's death on March 23, 1953, he eulogized his colleague in a brief statement: "Dufy's work will live." This prediction was not mere piety uttered in a moment of mourning, for during his long lifetime Matisse had seen too many gifted men achieve recognition only to lose it again with the passage of time. He also realized that the rising generation was rather scornful of the accomplishments of those who, like Dufy and himself, had grown to manhood in *la belle époque*. In the years after World War II, his own work had been challenged, and there had been a tendency to downgrade Dufy, to dismiss him as no more than a virtuoso decorator with a pleasant sense of color, or a witty illustrator.

Perhaps the time is still too short to test the validity of Matisse's prophecy. Nevertheless, in recent years Dufy's star seems to have risen again. The coldness and impersonality manifested in much recent art have caused some critics to wonder whether they have not been unfair to a civilized and sophisticated artist like Dufy, who in a very personal manner sought to glorify, through his elegant arabesques, French sensibility and charm. In addition, the decline in popularity of "Dufyesque" decor in hotel lobbies and homes has ended the mass production of pseudo-Dufys, and once again we can see what his genuine works are like. It might be said that an imitator's "Dufy"

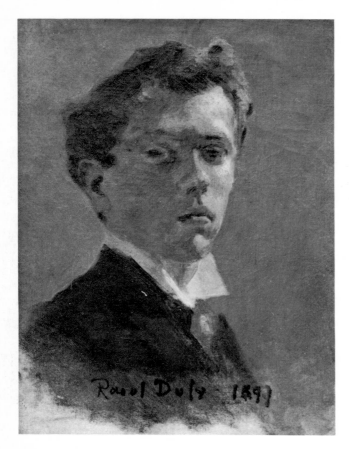

a legitimate heir to the eighteenth-century tradition of painters like Boucher, Fragonard, and especially Watteau. Certainly, Dufy was no more troubled by social and moral issues than these three predecessors. Unlike Hogarth or Daumier, he seems devoid of social conscience, nor does he resemble his contemporary Georges Rouault, social critic as well as mystic, whose subjects ranged from prostitutes and tragic clowns to the protagonists of the New Testament drama. Dufy's pictorial world definitely excludes the sordid, sad, or tragic. He was not unduly ruffled by two World Wars, or even by the Nazi occupation of France (though, during World War II, he was captured in the Pyrenees by a Russian unit fighting on the German side, mistaken for a member of the Maquis, and nearly shot). He was called "the Enchanter," and tried to live up to the role. Like Watteau, he depicted the amusements of the favored few, and as an artist and observer conveyed the impermanence of these *divertissements*. Two centuries earlier, Watteau had been fascinated by the atmosphere of the *fêtes galantes*, the graceful poses, the soft, colorful shimmer of silken gowns. However, he does not seem to have joined in the frivolity of these *fêtes*, the essence of which he distilled in a web of fine brushstrokes.

Dufy could be called the Watteau of the age of automobiles, de luxe trains, and motor yachts, or, perhaps, the twentieth-century Constantin Guys. The long perceptive essay which Charles Baudelaire devoted to his contemporary "Monsieur G." (as he called him) might also be said to capture some of the essence of Dufy's work: "He deliberately served a function which other artists scorned and which, above all, requires a

is like a toy airplane that hovers only for a few seconds above the ground, while an authentic Dufy has real wings on which to soar into a sunny sky.

In any case, Dufy's works did not disappear from the scene after the customary memorial exhibitions had closed. In the 1960s, there were large shows in Switzerland, Germany, England, the United States, and of course his native land. In 1969, a Dufy of 1906 sold at auction for $140,-000. While it is true that—largely due to their extreme rarity—Dufys of the Fauve period are likely to fetch more money than his later works, some of his paintings of the twenties and thirties have commanded prices up to $200,000.

Art historians now tend to see him as the engaging painter of *la douce France* that he was,

man of the world to fulfill. He relentlessly pursued the fugitive, fleeting beauty of present-day life, whose distinguishing characteristic . . . we have called 'modernity.' "

Working rapidly and often from memory, Guys—Baudelaire's "painter of modern life"—set down in clever, sometimes brilliant pen-and-ink sketches the high society of the Second Empire as it paraded in its fine clothes on the boulevards or rode in its elegant carriages. As an artist, Dufy—who once made a free copy of Guys' *Reception of a French Officer by an English*

2. VILLAGE. 1900. Drawing, 25 ½ × 20″. *Collection Ogden Phipps, Roslyn, Long Island*

3. Jean Dufy. FLOWERS. Undated. Oil on canvas, 13 ¾ × 10 ⅝″. *Wally F. Galleries, New York City*

Admiral—was attracted to the same milieu. Yet he was both more ambitious and more energetic than Guys, who was content to be a magazine illustrator and who neither signed his works nor exhibited them publicly. As entries in his notebooks show, Dufy pondered a great deal over his art, and practiced incessantly in order to improve his methods and techniques. With such sincere dedication, it is unfortunate that Dufy was not more discriminating in choosing those works that he allowed to leave his studio and those that he retained—or may have destroyed—as mere sketches. Had he been more selective, he might

have avoided the tenacious, though misleading, image of a mass-producer exploiting a successful mannerism. But it is a rare artist who, after years of privation, does not capitalize on his fame, yielding to the persuasions of greedy dealers and the temptations offered by a public more interested in the signature than the quality of a picture!

Admittedly, of all the celebrated painters active in the first half of this century, none has been accused more often than Dufy of lacking seriousness. Moralistic critics, however, have overlooked the brilliance of his performance

4. PORTRAIT OF GASTON DUFY. 1902. Oil on canvas, 24 3/8 × 20 1/8". *Galerie Louis Carré, Paris*

5. Eugène Boudin. THE EMPRESS EUGENIE AND HER SUITE. *The Glasgow Art Gallery, Scotland. The Bunnell Collection*

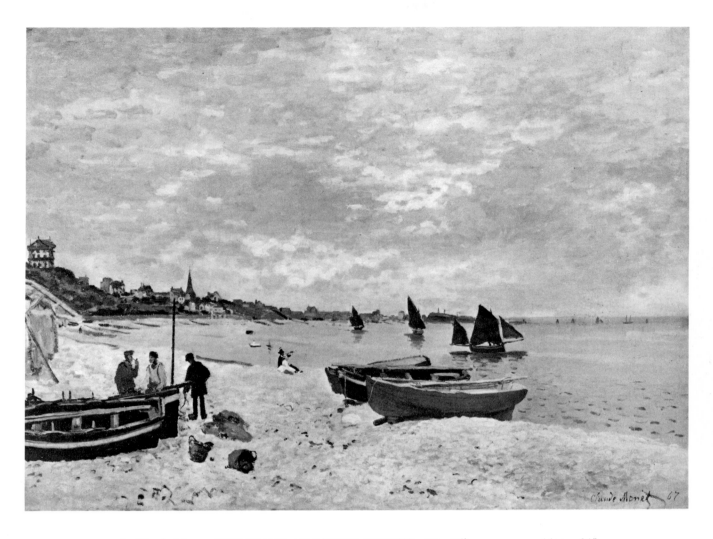

6. Claude Monet. THE BEACH AT SAINTE-ADRESSE. 1867. Oil on canvas, 29 ½×39 ¾".
The Art Institute of Chicago. Mr. and Mrs. Lewis L. Coburn Memorial Collection

manifest in even his lesser works, and have tended to confuse his subjects with his art, attaching to his choice of motifs the stigma of superficiality. Nevertheless, in the final analysis, *how* a man paints is more important than *what* he paints. "A well-painted turnip is more significant than a poorly painted Madonna," the German artist Max Liebermann once said. Dufy's repertory was largely composed of bathers, nudes, garden parties, receptions, regattas, race courses, yacht clubs, circus performers, bull fights, orchestras, birds, and flowers, as well as vistas of cities, beaches, and wheatfields. There are also a few portraits and self-portraits, some witty mythological adaptations, and free versions of famous paintings of the past. Dufy also executed commissioned work—book illustrations, cartoons for tapestries, textile designs, and murals. If his *oeuvre* lacks social and religious significance, by and large it can be said that most of his themes were, *mutatis mutandis*, the same as those favored by the Impressionists, and they have not been

11

accused in our century of wasting their time on trivialities.

He was a hedonist, but one who shared his happiness with others. "Dufy is pleasure!" proclaimed Gertrude Stein, won over by the poetry inherent in his art. Dufy endeavored to dispense

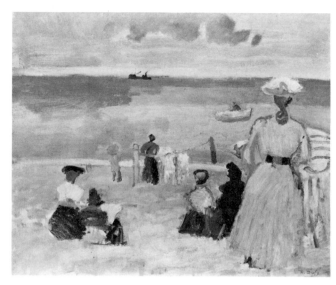

7. BEACH. 1905. Oil on canvas, 18×21 ⅝″. *Collection William ͡ernbach, New York City*

8. Henri Matisse. LUXE, CALME ET VOLUPTÉ. 1904–5. Oil on canvas, 35×45 ¾″. *Collection Madame Cachin-Signac, Paris*

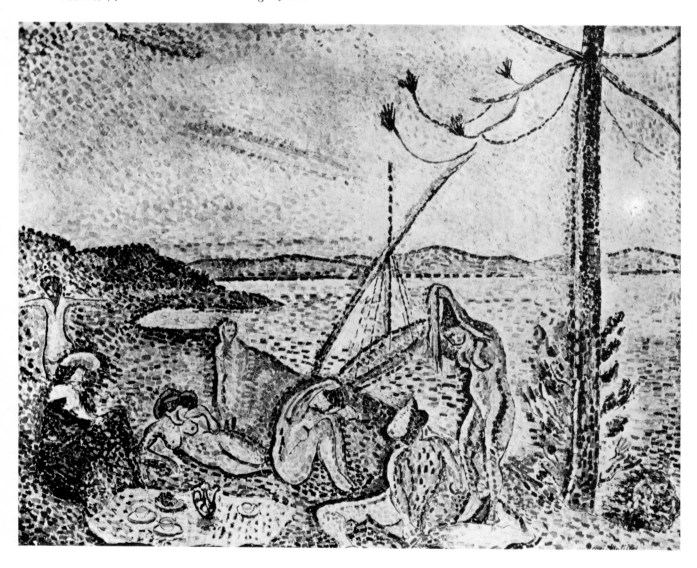

12

pleasure: "My eyes were made to efface what is ugly," is one of his most widely quoted dicta. Even before his fame spread to all the art centers of the world, he was adept at effacing the ugly, to judge by the early pictorial renderings of his native city. Le Havre, where he was born on June 3, 1877, is one of the least attractive cities of France. Guidebooks tell the hurried traveler that it has "few points of special interest," and advise him not to linger. Indeed, this busy seaport on the north bank of the Seine estuary is devoid of charm, and little of architectural importance was lost by its destruction in World War II.

Le Havre nevertheless had something to offer to that alert boy, Raoul-Ernest-Joseph Dufy. In this bustling Channel port—second only to Marseilles in French maritime importance—he eagerly watched the tumult, the crowds, the constant movement of men, vehicles, and ships, the floods and tides, the cyclical changes in the northern sky. It is conceivable that all these rhythms contributed to the animation so characteristic of his pictures. Eugène Boudin (1824–1898) and Claude Monet (1840–1926) both painted for many years in the city or its vicinity. Georges Braque (1882–1963) was eight when he and his family moved to Le Havre. But except for Dufy, the only native of the city to make a name as a painter was Othon Friesz (1879–1949).

Raoul Dufy's life was as bare of dramatic events as it was rich in accomplishments. His childhood milieu was one of genteel poverty. His father, Léon-Marius Dufy, was the accountant of a small metals firm, but his heart was not in commerce. In his spare time, he was a choirmaster and organist. Dufy's mother (*née* Marie-Eugénie-Ida Lemonnier) had her hands full with house, garden, and nine growing children—four boys and five girls. In all likelihood, the father,

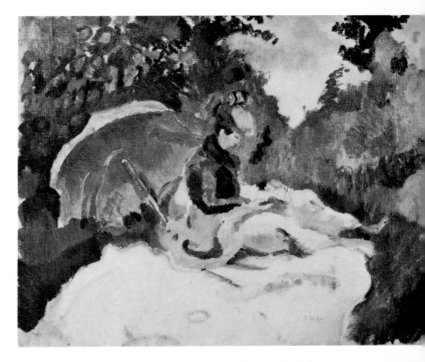

9. MME DUFY SITTING IN THE GRASS. 1906. Oil on canvas, 21 1/4×25 5/8". *Wally F. Galleries, New York City*

despite his own artistic inclinations, would have liked to see his sons enter professions that would ensure them financial security. Yet Léon sang in the parish choir and played the organ in the local cathedral, Gaston became a music critic, and the two other sons painters. For years Jean Dufy (1888–1964) worked at the side of his older brother Raoul, with whom he collaborated in one major venture, the huge "Electricity" mural for the Paris World's Fair of 1937. He often exhibited his pictures (which, in style and choice of subject, bear an uncomfortable resemblance to Raoul's work), but he never achieved more than a modicum of success.

There were so many mouths to feed in the Dufy family that Raoul's formal education was cut short. Like other budding artists, he was a mediocre student anyway, spending too much time drawing in the margins of his exercise book.

13

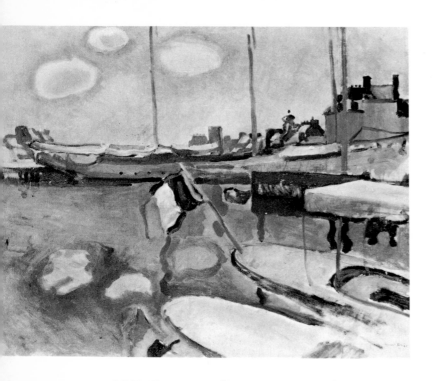

10. LE HAVRE. 1906. Oil on canvas, 23 ½×29″. *Collection Mr. and Mrs. Frederic W. Ziv, Cincinnati*

vince his father, owner of a drygoods store on St. Thomas, that he did not wish to work as a clerk any longer and was not suited to a business career. Manet went to sea as an apprentice aboard a cargo ship. Mordecai Pincas discovered that his son, Julius—subsequently to become famous as Jules Pascin—would never do well in commerce when he saw him sketch caricatures of customers in the ledger.

In any event, the elder Dufy was not an insensitive father bent on thwarting his son's artistic aspirations. He did nothing to prevent Raoul from attending evening courses at the municipal school of fine arts. There the young artist met and became a close friend of Othon

11. 14TH OF JULY, 1906. Oil on canvas, 18 ⅛×15″. *Collection A. Bellier, Paris*

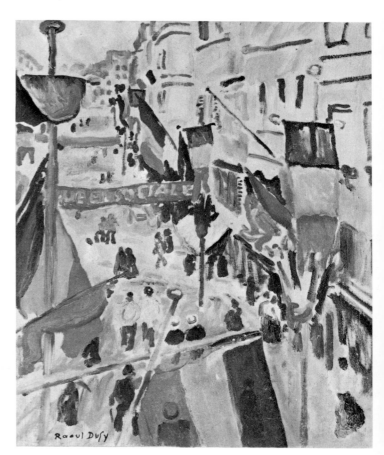

At the age of fourteen, he left St. Joseph's *collège* (a grammar school) in order to earn money. For several years he held a minor clerical position with Luthy & Hauser, a Swiss export-import company whose offices overlooked the harbor. His task was to check the arrival of consignments of coffee. Occasionally he helped load sacks of cargo onto the *Harry Scheffer*. A pen-and-ink sketch made in his last years shows this Rotterdam-bound ship anchored at the pier.

Despite his meagre academic background, the mature Dufy expressed himself, in writing as well as in speech, with great elegance, and counted among his friends some of the most erudite French *literati* and poets of his generation. But he was, of course, not the first artist to start out in a humble way at a job not at all related to his interests. Young Corot worked as an errand boy. Pissarro ran away to Venezuela in order to con-

14

Friesz, with whom he roamed the countryside on weekends. Their teacher, Charles Lhuillier, an ardent admirer of Ingres, had been a pupil of Alexandre Cabanel, famous for his *Birth of Venus* purchased from the Salon of 1863 by Napoleon III. In a quick pen-and-ink sketch, executed decades later, the aged Dufy once recaptured the atmosphere of the studio: Lhuillier, wearing a peaked cap and smoking a pipe, watches his students copy large plaster casts of antique sculpture. "We looked up to him with great respect and admiration, for he was a true artist, a great draftsman in the classical style," Dufy reminisced about this pedagogue, who was also

12. 14TH OF JULY, 1907. Oil on canvas, 41×33″. *Private collection, Paris*

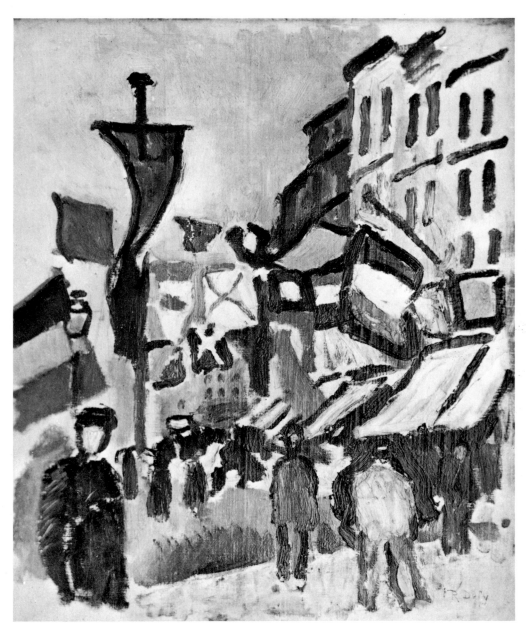

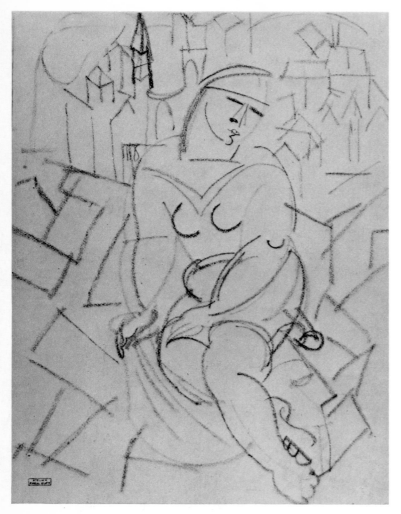

over, Lhuillier was wise enough not to impose his own aesthetics on the young men he taught, and this too they appreciated. Obviously, Lhuillier's name would not be remembered today save for the achievements of his three outstanding pupils. Although bound by tradition, he commanded their respect and fanned their enthusiasm for art.

Dufy left the school to do his stint in the army. He served for one year only, for his brother Gaston then volunteered for a post as a flutist in the regimental band. Since the law did not permit two brothers to serve at the same time, Raoul was released—in time to make use of a grant awarded him by the municipality of Le Havre. It enabled him to go to Paris to enroll at the Ecole des Beaux-Arts. There his instructor, Léon Bonnat (1834–1920), though a contemporary of the Impressionists, harked back to the *chiaroscuro* of a Ribera in the portraits, religious compositions, and Italian genre scenes for which he was well known. He was not a tyrant, and he was fond of Dufy. Yet on one occasion he scolded him for his use of fresh, light color, while on another he paid him a left-handed compliment: "I think you will eventually draw very well." Dufy's other teacher, Jean-Paul Laurens, was better able to grasp the young painter's strivings, and in Bonnat's absence uttered words of encouragement.

Too disciplined to drop out, Dufy endured the school's rigid instruction for four years. He left convinced that educational institutions were a hindrance rather than a help and that anyone with unusual talent would always have to struggle against the Establishment and its propagandists. Nevertheless, it is hard to believe that these four

the teacher of young Georges Braque.

Lhuillier put the strictest emphasis on drawing. His pupils were not allowed to use color, which was held out to them as a reward only after years of training in draftsmanship. Dufy's irrepressible *joie de peindre* may possibly have developed as a reaction to this prohibition. By the same token, he had every reason to be grateful to *père* Lhuillier for having fostered his drawing skill, for this rigorous training subsequently enabled him to use pencil or pen with a virtuosity akin to that of a violinist with his bow. More-

years were a total loss. Matisse, in a letter to the director of the Philadelphia Museum of Art, once stressed the "slow and painful preparation" necessary for the growth of a painter. He warned the young visitors to his exhibitions, who might see only "the apparent facility and negligence in the drawing," against believing they could dispense with certain necessary efforts. The years in Paris at the Ecole des Beaux-Arts certainly augmented Dufy's skill. Indeed, he achieved such virtuosity with his right hand that he deliberately switched to the still untrained left, which he came

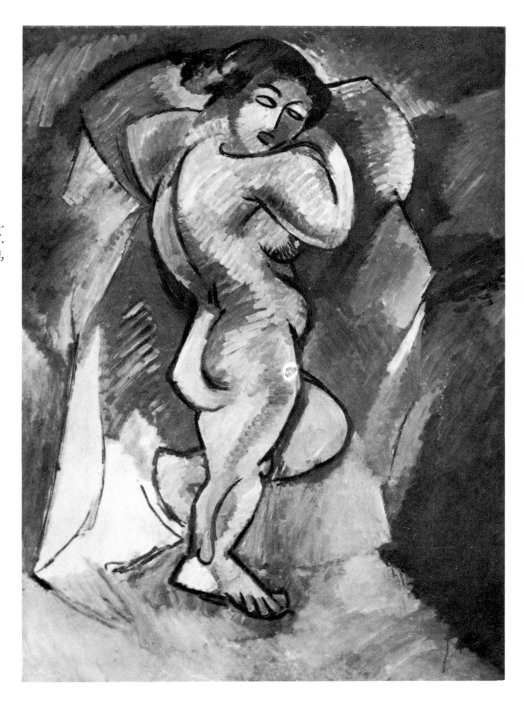

14. Georges Braque. BATHER. 1907. Oil on canvas, 55⅛×39". *Collection Madame Marie Cuttoli, Paris*

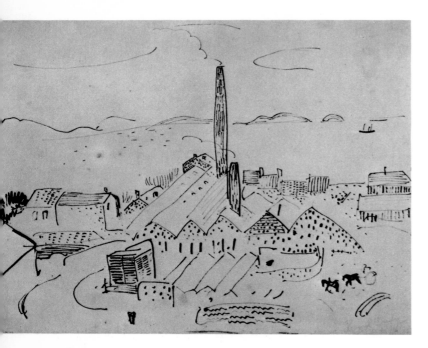

eventually to prefer.

Even as a youth, Dufy did not expect schools alone to provide him with all the stimuli and background he needed in his development as an artist. Like Degas, he early recognized the importance of studying the masters. Prior to his arrival in Paris, he had discovered the museum in his native city, with its Old Masters and, in particular, the many paintings of Boudin—all of which he came to know by heart. At the larger museum in Rouen, he had been able to see works by Poussin, Géricault, and Corot. There he had become enraptured by Delacroix' *Justice of Trajan*, a large work inspired by Rubens. It was this canvas that had prompted such a connoisseur as Théophile Gautier to exclaim, "Rarely has a painting presented the eyes with so brilliant a feast." Undoubtedly, young Dufy was captivated both by the grandeur of Delacroix' composition and its marvelous eruption of glowing colors.

No Impressionist pictures, however, could be seen in either city. The capital was more pro-

gressive. By 1900, the Impressionists had become respectable there, and the erstwhile rebels were even represented in an exhibition of French painting at the World's Fair. Nevertheless there were pockets of resistance. A few years earlier, the academician Jean-Léon Gérôme had warned the State against accepting the Caillebotte Bequest, which included works by Manet, Monet, Sisley, Renoir, and other Impressionists: "For the nation to accept such filth, there would have to be a great moral decline." Eventually part of the collection was accepted and placed in the Luxembourg Museum, where young Dufy saw and admired it. Works by Impressionists and Post-Impressionists—among them Gauguin and Van Gogh—could be seen at commercial galleries in the Rue Lafitte. At the Louvre, Dufy stood spellbound before the luminous landscapes of Claude Lorrain (eventually, he was to paint his homage to this artist) and Giorgione's *Concert Champêtre*.

In his student days in Le Havre, Dufy had painted portraits and self-portraits in a pre-Impressionist style dominated by various shades of brown (he appears in one of these pictures a bit dandified, wearing a high white collar and flowing cravat, his expression dreamy and aloof). Later in Paris, he succumbed to the influence of Monet and Pissarro, and for several years painted metropolitan streets and Normandy beaches in a manner that was already slightly anachronistic. Yet his timid, middle-of-the-road style gained him entrance, with *End of Day at Le Havre*, to the 1901 group show of the Société des Artistes Français (the reorganized Salon). Two years later he began showing at the Salon des Indépendants (where the Nabi painter Maurice

16. HAUTE VOLTIGE. 1906. Drawing, 25¼ × 20″. *Collection Henri Gaffié, Beaulieu-sur-Mer*

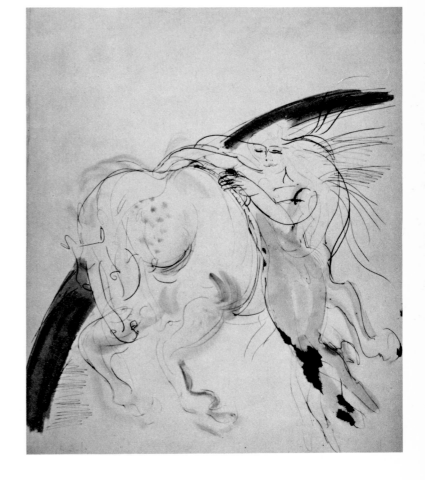

17. FISHING FOR CRABS. 1906. Drawing, 22 × 17¾″. *Collection Henri Gaffié, Beaulieu-sur-Mer*

Denis bought one of his works). During this period he shared lodgings with Friesz at 12 Rue Corot, in the heart of Montmartre. But he was hardly a typical Montmartrois—serious and well-groomed, he wore clean shirts, went to classical concerts instead of music halls, and avoided the bars and cabarets.

Had he continued to work in the Impressionist vein, Dufy would have avoided trouble. For, Gérôme's outcry notwithstanding, the Impressionists had at last become fashionable, and even their fellow-travelers and imitators now found it possible to make a living. Had his development stopped here, Dufy would be remembered as a minor painter on the level of, say, Jean-François

19

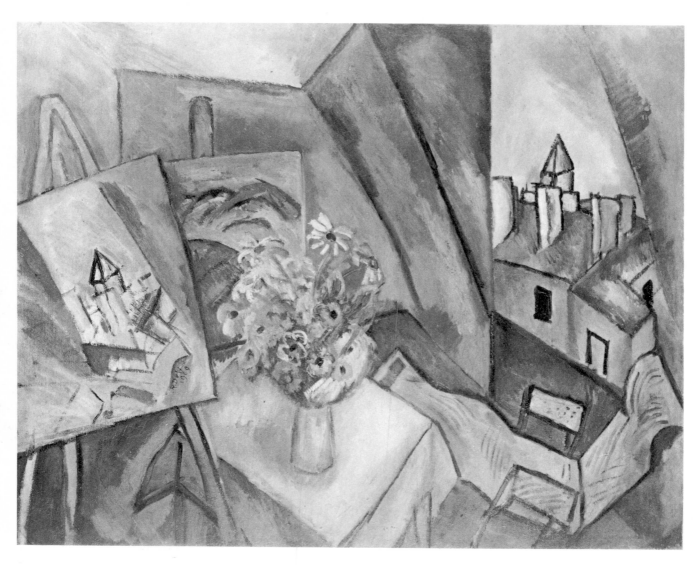

18. THE STUDIO. 1909. Oil on canvas, 25 ½×31 ¾". *Private collection, Paris*

Raffaëlli, who was extremely popular with a public satisfied by the superficial charm of paintings that please the eye. But something compelled Dufy to veer in the direction of Matisse even before the celebrated Salon d'Automne of 1905. A few of his pre-Fauve pictures have color accents that are too strong to fit comfortably in the category of Impressionism.

The story of the "Cage of Wild Beasts" at the Salon d'Automne is so well known as to have become legend. Walking into one of the Salon rooms in the late fall of 1905, Dufy was overwhelmed by what he saw—violently colored canvases by Marquet, Puy, Manguin, Van Dongen, Derain, Rouault, Vlaminck, by his friend Othon Friesz, and, of course, by the group's acknowledged leader, Henri Matisse, eight years his senior. As Dufy was to recall many years later, speaking of his first confrontation with *Luxe, Calme et Volupté* by Matisse: "At the sight of this picture I understood the new *raison d'être* of painting, and Impressionist realism lost its

charm for me as I beheld this miracle of creative imagination at play, in color and drawing.''

Much as he admired the daring of these artists, united in acknowledging the emotional value of color, and in their efforts to liberate it, Dufy was not quite ready to plunge into this revolutionary stream. Most of his work since his arrival in Paris looked pale compared to these orgies of ultramarine, vermilion, orange, yellow, and green thrown onto the canvas, often with little concern for the actual colors of the subject. He had become friendly with Albert Marquet, a close associate of Matisse, and began discussing with him these ideas so novel to one who had

19. THE ALLIES. 1914. Oil on canvas, 19 ½ × 19 ½''. *Collection Henri Gaffié, Beaulieu-sur-Mer*

20. LE BOEUF. 1911. Woodcut, illustration for Guillaume Apollinaire's *Le Bestiaire, ou le Cortège d'Orphée*

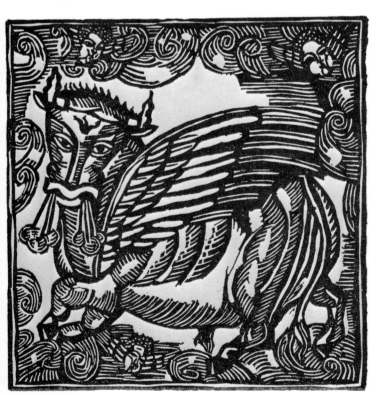

been taught in the old tradition to paint only what he saw.

For a while Dufy continued to work in his customary manner, but finally he arrived at an impasse. As he was to say many years later, he had grown tired of always remaining ''outside the picture itself.'' Settling down with his equipment on the beach of Sainte-Adresse, near Le Havre, he asked himself the question that was to shatter the aesthetics he had been taught: ''How can I use these means [the pigments and brushes] to express not what I see, but what *is*, what exists for me, my reality?'' His answer indicated that he must blaze a new trail for himself: ''I had discovered my own system. Its theory is simple. To study sunlight is a waste of time. Light in painting is something quite apart: it is composed, it is arranged, it is colored.''

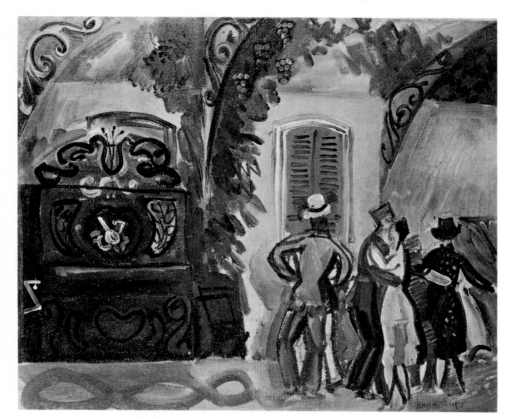

21. THE MECHANICAL PIANO.
1915. Oil on canvas, 18×21 ½″.
Private collection

22. OLIVE TREES. 1919. Oil on
canvas, 18 ¾×24 ¼″. *Collection
Henri Gaffié, Beaulieu-sur-Mer*

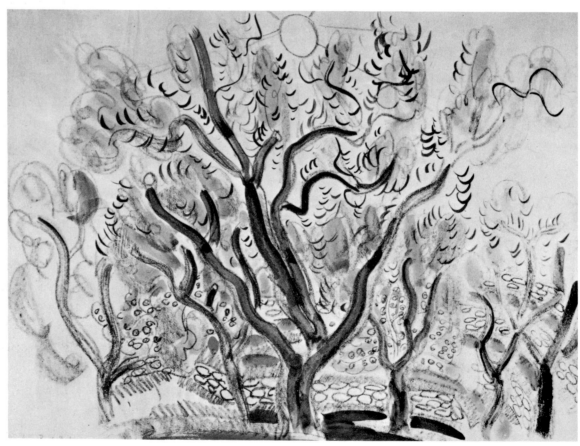

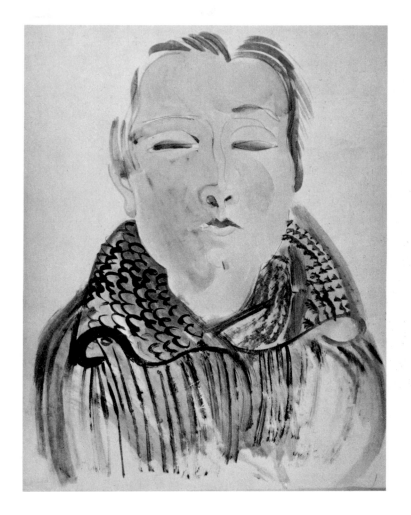

23. THE JAPANESE. 1920. *Collection Henri Gaffié, Beaulieu-sur-Mer*

He succeeded in finding a dealer, Mademoiselle Berthe Weill. At her premises—which resembled a junkshop more than a regular gallery—she showed not only the "Wild Beasts," but also works from Picasso's Blue Period, and, subsequently, Modigliani's nudes. (Her foresightedness brought so little financial success that when she died in 1951, a collection had to be taken up among the artists she had valiantly tried to promote, to provide her with a decent burial.)

The artist went on a number of painting expeditions with Friesz to Fécamp, and with Marquet to Trouville, then a fashionable seaside resort in Normandy. Often Marquet and Dufy would set their easels side by side. Their renditions of the cheerfully vulgar billboards at Trouville are so similar that were their canvases unsigned, only a knowledge of their personalities would enable us to distinguish their work. On this basis we would attribute to the sociable and jovial Dufy the paintings of vacationing crowds, and to the solitary and withdrawn Marquet those in which inanimate shapes and forms assume greater importance.

While it lasted, Fauvism—"color for color's sake," as Derain defined it—shook the foundations of a tradition that subordinated the painter's vision to the appearance of nature and limited his artistic scope to phenomena as perceived by the retina. Fauvism, though related to the philosophies of Bergson and Croce, which stressed man's intuitive faculty, contained two conflicting tendencies, one represented by Matisse, whose professed goal was to create an "art of balance,

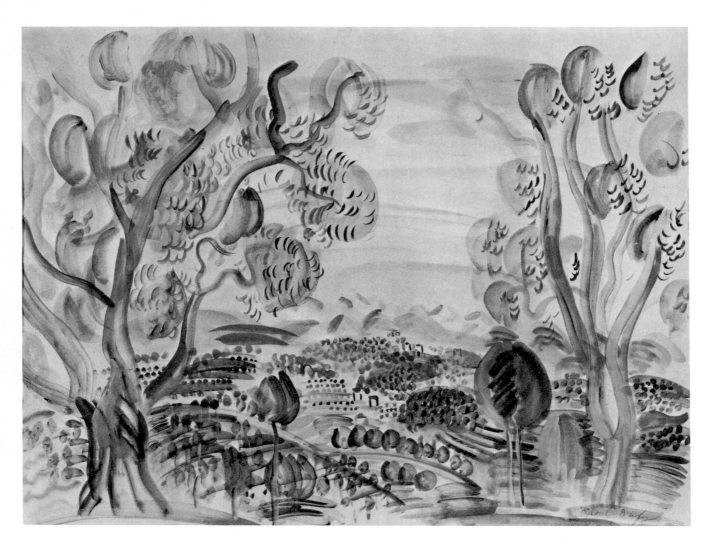

24. OLIVE TREES BY THE GOLFE JUAN. 1927. Watercolor, 20×26″. *The Tate Gallery, London*

of purity and serenity" and who insisted on "conception," on "a clear vision of the whole right from the start." His antagonist, Vlaminck, who wished to paint with "his heart and his guts" without worrying about style, embodied the other. He believed that the salvation of painting lay in the unrestrained use of color, and was rebuked by the more moderate Derain for squirting raw pigments directly from the tube onto the canvas like so many "dynamite cartridges."

Even though he, too, abandoned nuances, soft shadings, and subtle transitions, Dufy was one of the milder Fauves, tempering the violence of hot color with ochers and browns, and modifying the Fauve rejection of form by drawing strong contours with the brush. Moreover, by 1909 the "ferocity" in virtually all of the Fauves but Matisse had given way to austerity and restraint. All but *le roi des Fauves* turned their backs on everything that only yesterday they had proclaimed with the conviction of religious fanatics. Among the sobering influences had been the large Cézanne memorial exhibition. As for Dufy, in 1909 he joined Braque, another ex-Fauve, at

L'Estaque, near Marseilles, where Cézanne had produced some of his most forceful pictures. From Cézanne, the two borrowed the geometrization of form and also adopted his largely cool palette.

In his Cézannesque period, which lasted only a couple of years, Dufy's forms are starkly angular rather than curved, there is little space recession, and the paroxysmal quality of color is avoided. But just as Dufy never became an unquestioning follower of Matisse, neither did he follow Braque in the steps that led logically to Cubism. "I don't follow any system," he once said. "All the laws you can lay down are only so many props to be cast aside when the hour of creation arrives." Thus, he could not for long confine himself to Braque's muted ochers and viridians, nor simplify and even distort his subjects so that they were no longer recognizable. Dufy could never have said, as did Braque at the height of his Cubist period,

26. THE PORT OF MARSEILLES. 1925. Oil on canvas, 21 7/8 × 25 5/8". *Private collection, Paris*

25. VIEW OF SAINTE-ADRESSE. 1924. Oil on canvas, 21 3/8 × 25 3/4". *Formerly Perls Galleries, New York City*

"The subject is like a fog that has lifted, allowing the objects to appear."

Braque had first met Picasso in 1907 when the poet and critic Guillaume Apollinaire had taken him to the Bateau-Lavoir to see *Les Demoiselles d'Avignon*. In the fall of 1909 their relations ripened into close friendship, and together they developed what became known as Analytical Cubism. Matisse, hostile to the Cubist revolution, went on to create his celebrated *harmonies* in red and blue. He was an official of the Salon d'Automne which rejected Braque's early Cubist landscapes of L'Estaque.

Dufy profited by his association with both Braque and Matisse. After a period as a print-maker and industrial designer, during which he had little time for painting, he came back to Fauvism, but to a rather purified and elegant version. Braque's proto-Cubism, on the other

25

27. FLOWERS. c. 1926. Gouache on canvas, 23 5/8 × 26 3/8". *Private collection*

hand, taught him how to invent a new reality on canvas instead of adhering to existing vistas (many Fauve pictures differed from those of the Impressionists only by their arbitrariness of color), and how to avail himself of light that does not radiate from such sources as the sun or a lamp, but from the white of the canvas itself. He developed a feeling of complete freedom that would bear fruit as soon as economic pressure had ceased and as a painter he could abandon himself unrestrainedly to his joyous vision.

But this creative freedom was still an im-

possibility in a world in which the artist must support himself financially. In 1910, Dufy, now thirty-three and married, could no longer afford to "dream like a king" while "living like a pauper," as he had done earlier. Nobody wanted to handle his most recent work and he was therefore penniless. A makeshift solution was found when the Dufys accepted the hospitality of a philanthropist who placed his Normandy farm at the disposal of married artists and allowed them to work there rent-free. It was there that Dufy met André Lhôte with whom he made a trip to

nearby Evreux to see the fifteenth- and sixteenth-century stained glass windows in the cathedral of Notre-Dame—an experience that led to greater depth and intensity in his colors.

It was there also that Dufy began his first in a long series of book illustrations—wood engravings for Guillaume Apollinaire's *Bestiaire ou le cortège d'Orphée*. Apollinaire had composed a four-line allegorical poem about each of the many beasts that he envisioned as following Orpheus and his lyre. Each page was devoted to a single poem and below it appeared Dufy's large and vigorous print, portraying each animal with great individuality in a bold contrast of black and white. For all its charm, wit, and visual appeal, the book sold only fifty copies in its original 1911 edition of one hundred and twenty copies, bankrupting the publisher (a facsimile of the book was issued in 1919 in a reduced format; copies of the first edition are now so rare and sought after by bibliophiles that they fetch $5,000 or more).

By 1911, Dufy was far from unknown. While he had only a single one-man show to his credit, sponsored by Berthe Weill, he had frequently exhibited at the Salon des Indépendants and the Salon d'Automne. But critical acclaim did not mean economic security, and when Paul Poiret, *"le grand couturier,"* suggested that Dufy execute woodcuts for textile printing, the financially desperate artist accepted gladly. He has been criticized for this collaboration with a commercial enterprise, and with later ventures of a similar kind. But Dufy knew of the hardships suffered by men whose work he had admired and emulated in his youth—Monet, who once tried to drown himself; Pissarro, who could not afford to buy stamps for letters to his son; Van Gogh, whose pictures did not sell in his lifetime.

Actually, the dichotomy of the fine and the applied arts is a false one, an absurd invention of nineteenth-century aesthetics. No such split

28. RESERVOIR AT GOLFE JUAN. 1927. Oil on canvas, 18 1/8 × 21 3/4". *Collection Mr. and Mrs. Henry A. Markus, Chicago*

29. HARBOR AT DEAUVILLE. 1928. Oil on canvas, 13 1/8 × 16 1/8". *Collection Mr. Pedro Echeverrio Vallenilla, Caracas, Venezuela*

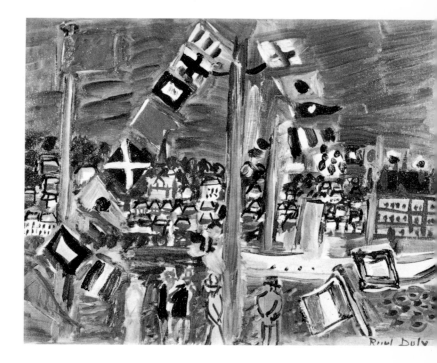

existed in earlier times. Some of the greatest Renaissance masters, for example, embellished *cassoni* or marriage chests; Watteau designed clothes and adorned sedan chairs and harpsichords for an interior decorator. There is no reason why outstanding artists should not participate in making utilitarian objects; what is regrettable is that they do not do so more often, leaving such things to be designed by the untalented.

"We used to dream of dazzling curtains and gowns adorned in the taste of Botticelli," Poiret reminisced. He set up a textile shop in small premises on the Boulevard de Clichy in Montmartre, and hired a chemist who was experienced in dyes and printing inks. Dufy supplied the designs, engraved the woodblocks, and suggested the color schemes for fabrics from which Poiret's workers made scarves, shawls, and dresses (once Dufy observed with amusement that many women who did not like his paintings wore silken apparel entirely of his creation). After a year with Poiret, Dufy changed employers. The big silk firm of Bianchini, Atuyer & Ferrier in Lyons had offered him a fixed salary to become their art director.

The war ended the contract with Bianchini but otherwise produced no notable change in Dufy's life. Unlike Apollinaire, Braque, and other friends, he did not serve in the army. His sole

30. Photograph of Dufy's studio before 1930, showing "Homage to Claude Lorrain" on the easel

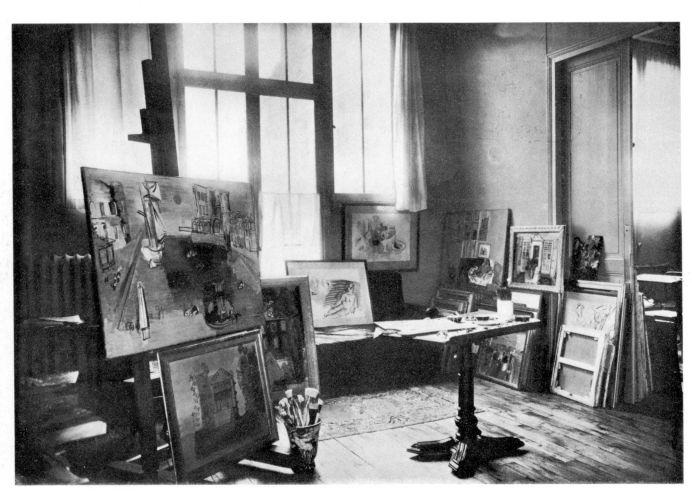

31. Photograph of Raoul Dufy, c. 1930

tion improved in 1921, when the well-known Galerie Bernheim-Jeune accepted him in their stable of artists and sponsored what after fifteen years was actually his second one-man show. Encouraged by this success, Dufy launched himself on a surge of activity which was only terminated by his death thirty-two years later. The number of oils, watercolors, gouaches, drawings, etchings, and lithographs he produced in that period has not been established, but they must number in the thousands. Yet the subjects are often similar, if not identical. Like Monet and Renoir, he frequently painted a large number of pictures on the same motif. His works are generally small in size—at least by current standards—conceived as they were to adorn private homes rather than public places.

Nevertheless, he is credited with having produced, in collaboration with his brother Jean and another artist, what is said to be one of the largest

contribution to the war effort consisted of wood-cuts for popular color-prints on patriotic themes. In 1917–18 he served briefly on the staff of the Musée de la Guerre, for which he acquired works by several fine artists, among them Dunoyer de Segonzac, who were still insufficiently appreciated. After the war, he resumed his relations with Bianchini, but soon decided he was spending too much time on activities only peripherally connected with his major interests, and he began gradually to cut down on his strictly commercial work (though he would return to it on occasion, as when he created hangings for Poiret's Seine barges at the International Exhibition of the Decorative Arts, or designed cartoons for the Aubusson and Beauvais textile weavers).

It might be said that a year or two after the war he "found himself" during a prolonged stay at the Riviera hill-town of Vence, where his art blossomed into those baroque arrangements of gaily colored curves and arabesques that have been termed "Dufyesque." His economic situa-

32. LANDSCAPE WITH BATHERS. c. 1930. Watercolor, 19 ¾×25 ⅝". *Private collection*

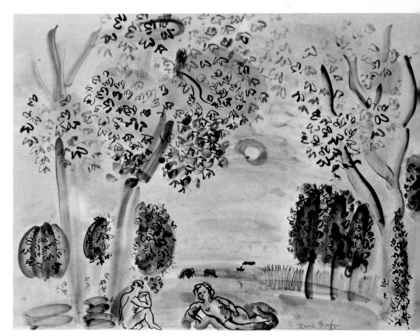

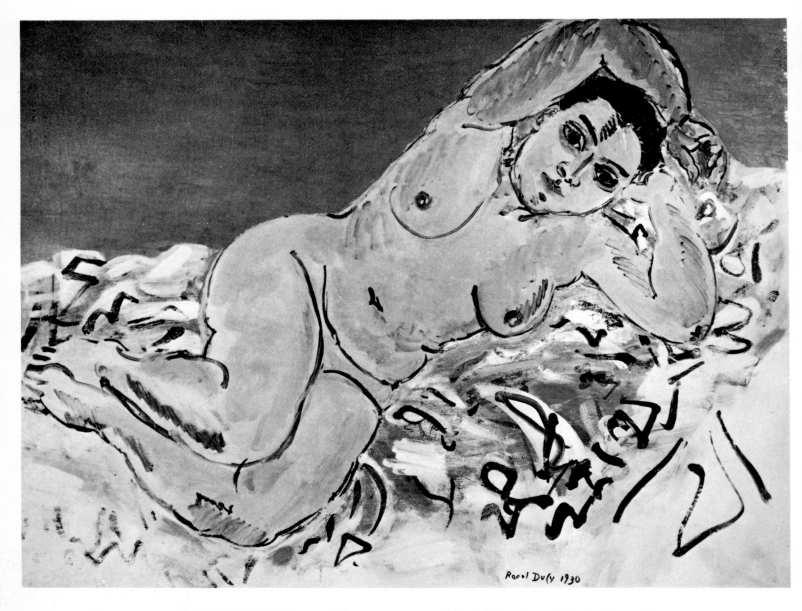

33. LARGE BLUE NUDE. 1930. Oil on canvas, 35×46 ½″. *Collection Henri Gaffié, Beaulieu-sur-Mer*

of contemporary murals, executed in oil on canvas for the Palais de l'Electricité at the Paris World's Fair of 1936–37. He was also commissioned to decorate the Monkey House at the Jardin des Plantes and the theater of the Palais de Chaillot, both in Paris. His great versatility, moreover, led him to design sets for ballets and plays, and he also worked with the Catalan potter José Llorens Artigas, creating vases as well as glazed tiles for bathroom and kitchen walls.

From 1911 until his death, Dufy kept a studio at the Impasse Guelma in Montmartre, even though he spent much time in the south of France and traveled to Italy, Sicily, England, and even Morocco. In 1937, he crossed the Atlantic to serve on the jury for the Carnegie Prize in Pittsburgh. World War II and the Nazi invasion caused him to seek refuge in southern France. But even when the

Nazis had occupied all of France, the unpolitical Dufy was not molested by them, and while some of his friends were dispatched to concentration camps, and others went into hiding or joined the Resistance, he went on working. He made sets for the Comédie-Francaise, and had large exhibitions at both the Palais des Beaux-Arts in Brussels and at the Galerie Louis Carré in Paris.

The only factor that marred his general well-being was the deterioration of his health. In 1938, at the age of sixty-one, Dufy had his first attack of rheumatoid arthritis. Despite excruciating pain, he continued to work until his hands no longer functioned. The aged Renoir had been plagued by the same disease, and as his son Jean

34. ASSURANCES. 1930. Oil on canvas, 25 ¾ × 6 ⅝″. *Collection Henri Gaffié, Beaulieu-sur-Mer*

35. THE PADDOCK. 1930. Gouache on canvas, 19 ¾ × 26 ¾″. *Collection Henri Gaffié, Beaulieu-sur-Mer*

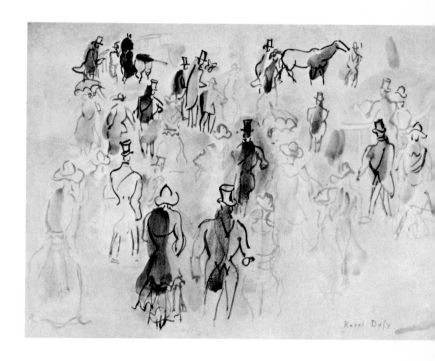

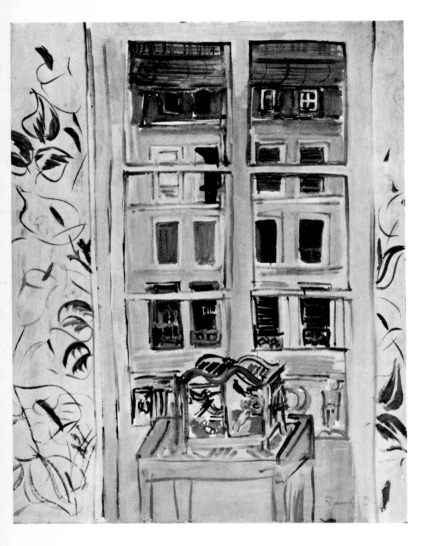

relates, "he had a little piece of cloth inserted in the hollow of his hand. His twisted fingers gripped rather than held the brush." But for Dufy, thirty-odd years later, a cure was available. Noticing Dufy's misshapen hands in a magazine photograph, Dr. Freddie Homburger, of the Jewish Memorial Hospital in Boston, invited the artist to America in 1950. Cortisone injections—a new treatment, available only to a few—finally restored the use of his hands, although he still needed crutches to walk. He visited New York City and then proceeded to Arizona, where he found the warm climate beneficial. Watercolors of scullers and sunbathers on the Charles River, New England churches, Times Square, the Brooklyn Bridge, horse racing at Belmont

36. THE CAGE. 1932. Gouache on paper, 25 ½ × 19 ¾".
Collection Mr. and Mrs. D. Gilbert Lehrman, Harrisburg, Pa.

37. VIEW OF THE PORT OF DEAUVILLE. c. 1933. Oil on canvas, 14 ¼ × 33 ⅞". *Perls Galleries, New York City*

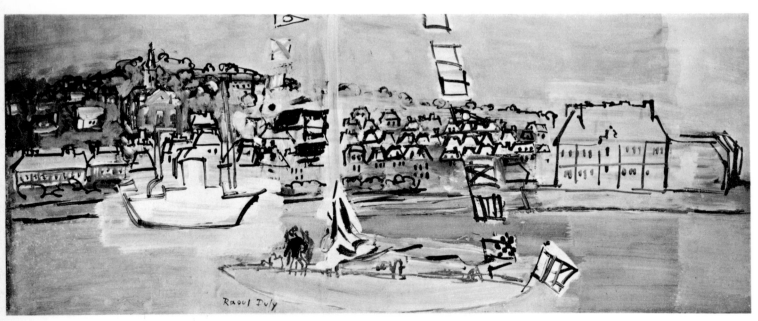

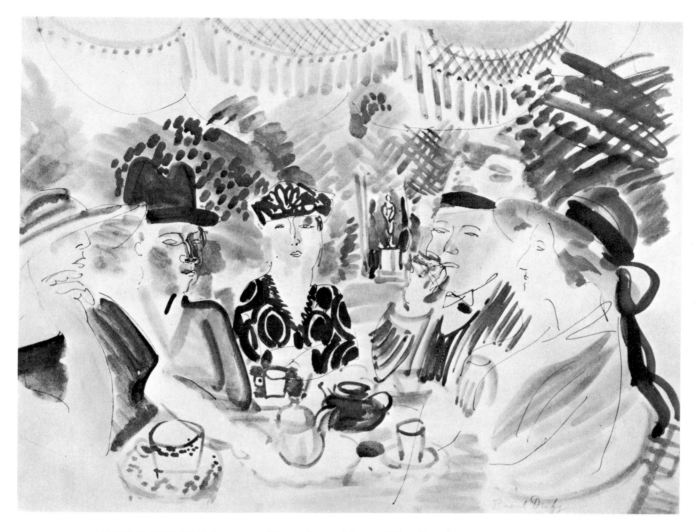

38. AROUND THE TABLE. c. 1935. Watercolor, 19 ⅛ × 24 ¾". *Collection Dr. and Mrs. Albert Shapiro, Baltimore*

Park, a night baseball game, and vistas of the southwestern desert are among the artistic fruits of this prolonged sojourn. To friends, who found his American paintings curiously Parisian, he pointed out: "There are, of course, differences between the American and the French scene, but they are superficial. A painted landscape is not nature anyway. Art is a creation, like music or poetry."

He returned to his homeland to live at Forcalquier, a historic town west of Avignon, said to be the driest locality in France. He, who had

already received many accolades, was now to experience his final triumphs. In 1952, Dufy went to Venice for the Biennale, where he won the first prize for painting (he divided the money between two younger colleagues). In the same year, a mammoth Dufy retrospective was organized at the Musée d'Art et d'Histoire in Geneva.

The winter of 1952–53 was extremely harsh. Dufy suffered a severe attack of pneumonia, but recovered, and, sitting on a revolving chair, resumed painting. On March 22, 1953, he went

out for an automobile ride. On his return, he was overcome by a heart attack, and died the following morning, a few weeks before his seventy-fifth birthday. His remains were interred in a hill cemetery overlooking the rooftops of Nice and the broad expanse of the indigo-blue Mediterranean he had loved so much. At the funeral, René Cassou summed up the feelings of those present, including fellow-artists, when he eulogized:

"A little of the joy of living has gone away with Raoul Dufy. We would love the sky and the earth less, from here on, if he had not left his immortal work."

Dufy has been described by those who knew him as a short, stocky man, who smiled even when he was in pain. His clothes were quietly elegant, and a flower often adorned his lapel. His face was fresh, rosy, and unwrinkled even when he was past seventy; his blue eyes sparkled with intelligence and kindness, and curly white hair framed his face. While he did not resemble the popular conception of an artist, this unassuming man made a deep impression on everyone

39. Photograph of Dufy in Normandy with his wife, c. 1935

40. THE FARM. Undated. Oil on canvas, 13 × 32 ¼". *Collection Mr. and Mrs. David Miro, Southfield, Mich.*

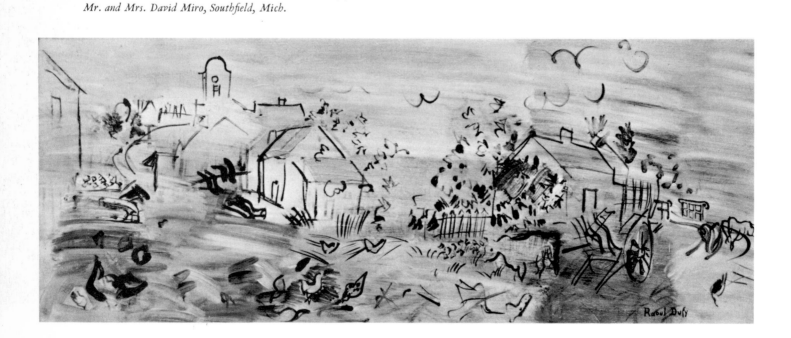

he met. As one admirer put it: "When he entered the room, it was like a flood of sunlight . . . there was an aura of majesty about him, a majesty born of graciousness, simplicity, and dedication."

Spared the agonies of such baffling innovators as Michelangelo, Van Gogh, or Picasso, Dufy understood his own aims and knew his limitations. As he once remarked with disarming frankness, "Every night I go to bed happy and exhausted, telling myself that I have worked to the limit of my resources and can die peacefully."

Tenderness, delicacy, and an unerring Gallic taste characterize even such early works as the gay beach scenes painted under the influence of Boudin and Monet. But had Dufy died before he was forty, as did Seurat, Van Gogh, and Modigliani, he would be remembered only as a minor follower of the Impressionists or as one of the lesser Fauves, whose career ended when the Cubists began to fracture natural forms in order to transform visual reality in a new way. He ripened slowly, spending many years learning to use color as an independent means of expression rather than as a mere complement of design, forgetting all the academic dogma about perspective, traditional modeling, and "accurate" drawing that had been instilled into him as a student. But when, having absorbed and digested all that others could teach him, Dufy's artistic uniqueness finally emerged, the astonished art world realized that a new name was to be added to the score of twentieth-century French masters.

For Dufy, who painted with the uninhibited gusto of a child while remaining a sophisticated, sharp-witted man of the world, was unique. His pictures, seemingly so unpremeditated and spontaneous, were actually the work of an artist in full control of his art. The best paintings of the mature Dufy are somehow reminiscent of the

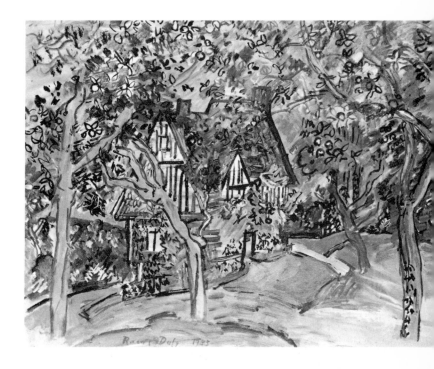

41. MANOIR DU VALLON. 1935. Oil on canvas, 18 ¼ × 21 ¾". *Collection Mrs. Jacquelyn Shlaes, Beverly Hills*

42. LANDSCAPE. 1935. Watercolor and gouache, 19 ⅞ × 26". *Private collection*

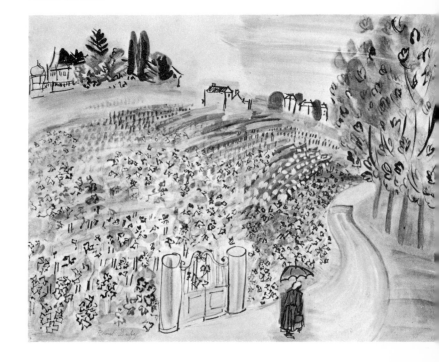

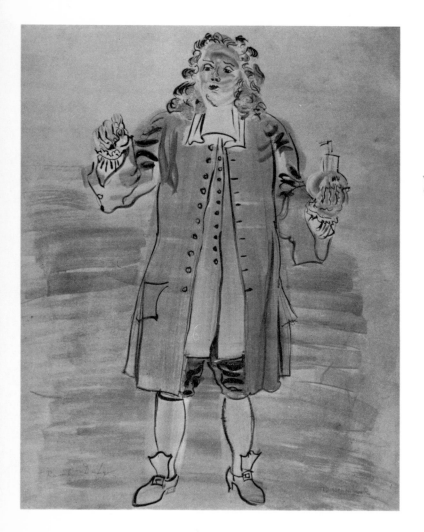

43. ELECTRICITY: MUSSENBROCK. 1936–37. *Collection Henri Gaffié, Beaulieu-sur-Mer*

44. LA FÉE ELECTRICITÉ. 1936–37. Oil on canvas, 20×25 1/4". *Collection Mr. Paul Haim, Paris*

45. RACETRACK AT DEAUVILLE. 1937. Gouache, 19 1/2×26". *Collection Mr. and Mrs. Robert G. Rifkind, Los Angeles*

doodles; and both were absorbed in revealing what the average man cannot see.

Klee once said, "I want to be as though new-born, to know absolutely nothing about Europe, to ignore poets and fashions, to be almost primitive." Delacroix must have had a similar idea when he praised the ability of "very great men" to keep "part of that impetuosity of their impressions which is characteristic of youth." Baudelaire even defined genius as "nothing more than childhood recovered at will," a childhood "equipped with the adult's capacities for self-expression and analytic powers which enable him to organize the mass of raw material which he has involuntarily accumulated."

Matisse, who sought to recapture the fresh vision characteristic of youth, to whom the entire world is new, possessed these capacities and powers. The same qualities are present in Dufy, whose work has often been compared to Matisse. To the end of his life, Dufy retained his astonishing exuberance and *joie de vivre*. He was not afraid of his instinct because it did not oppose his intellect. It was his instinct and not rational reflection that gave rise to the staccato calligraphy for which he is famous. Feeling was the prime mover behind his inimitable but, alas, so often imitated cursive shorthand, composed of little strokes—light, swift, graceful—that suggest rather than describe. Impulsively, he sometimes allowed these strokes of color to extend far beyond the linear boundaries of his forms.

One would have liked to hear directly from the artist precisely why he painted as he did.

offerings of children—his stick-like figures; his sun, conceived as a disc from which several rays emerge; his toy-like cars, trains, boats, and steamers; his highly personal perspective; his arbitrary use of color. One is reminded of Paul Klee, who openly proclaimed his debt to children's art. Klee was more introverted than Dufy, yet both men felt the unity between art and life; both covered reams of paper with curious scribbles that their teachers would have dismissed as

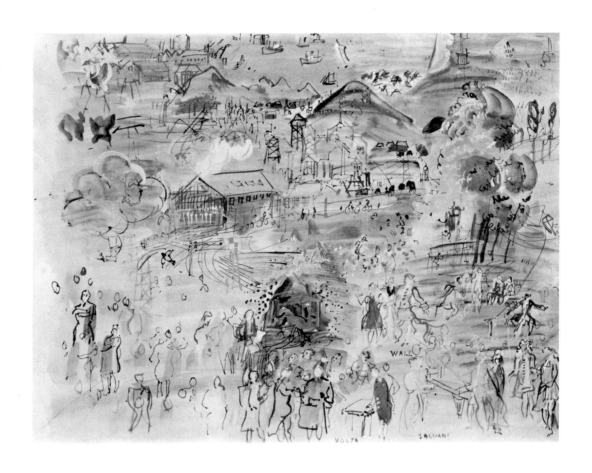

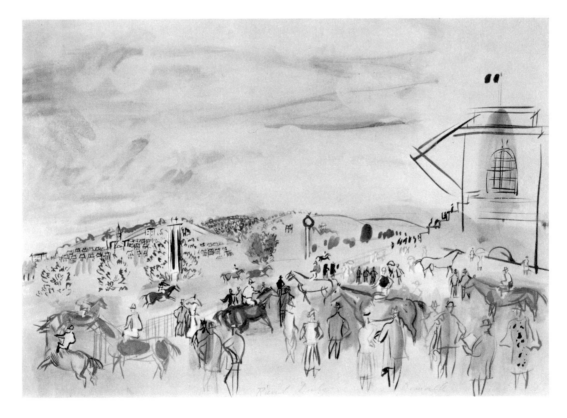

Unlike his more scholarly friend Matisse, Dufy did not leave many theoretical statements on his art and aesthetics. Some notebook entries, and especially a few aphorisms, have survived. "Nature, my dear sir, is only a hypothesis," he once quipped after being accused of taking too much liberty with his motif. Dufy's *Taormina*, for instance, is a poet's rendering of the ancient Sicilian town whose matchless beauty has been praised in many tongues. No color photograph can render, as did Dufy, its effervescent flavor, its crystalline air, the quality of aged greatness and perfect charm, enduring as the serenity of the surrounding hills. When Dufy painted Nice, he

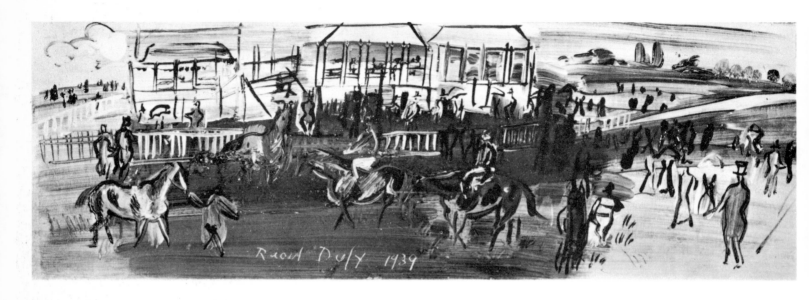

46. RACECOURSE AT EPSOM. 1939. Oil on canvas, 6 ⅝ × 18 ¼″. *Collection Mr. and Mrs. Charles S. Narins, Boston*

47. ORPHEUS CHARMING THE BEASTS. 1939. Oil on canvas, 24 ½ × 67 ¾″. *Perls Galleries, New York City*

imparted to the subject an Arabian Nights atmosphere. Painting Villefranche, he defied the canons of art to create an intense and unique vision.

Commenting on his palette, Dufy remarked, "Blue is the only color that preserves its own individuality in all its intensities." As if to prove the point, Dufy, as an old man plagued by arthritis, created his *Blue Mozart*. Washes of celestial blue dominate this homage to an artist who, as the young Schubert wrote, "stamped upon our souls . . . countless images of a brighter and better world." Dufy was ardently devoted to music (he spent the last evening of his life listening to a recording of a Wagner opera), and one of his favorite subjects was the orchestra. What attracted him was the orchestra's agitated movement, its patterns of form and sound, and these he superbly translated into vibrating line.

"If Fragonard could be so gay about the life of his time, why can't I be just as gay about mine?" Dufy retorted to those who scolded him for being a painter of the leisure classes, a purveyor of luxury for the elegant drawing rooms of the rich. The rebuke was, of course, absurd. The world needs religious artists like Rouault to expose vice and evil, but it also needs *chic* art, of and for the *grand monde*, to record its more light-hearted aspects, the movements of its rippling surfaces. Yet the soothing quality of Dufy's work has only a remote connection with the subject *per se*—the smartly dressed ladies and gentlemen enjoying their pastimes. Rather, the joy and gaiety in these paintings spring from preponderantly aesthetic elements: the seductiveness of the light, swift brushstrokes; the atmosphere of perfect calm arising from the complete harmony of the predominant colors; the decorative beauty of the dream-like patterns, often reminiscent of the Orient.

His confident statement that his eyes had been made to efface all that was ugly, quoted above,

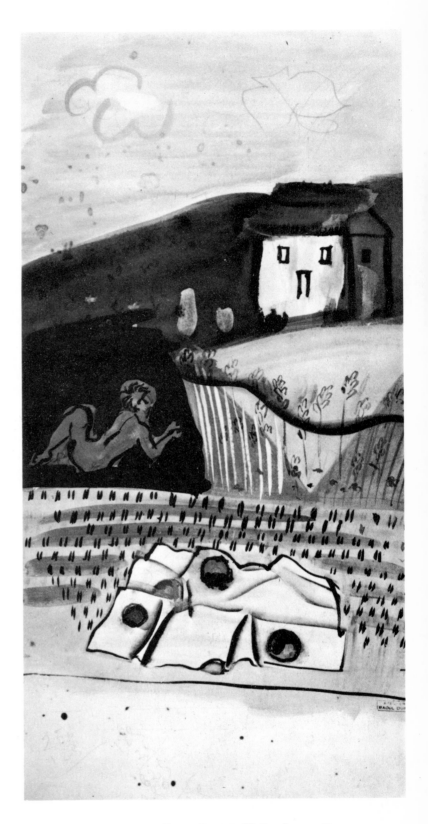

48. COLLIOURE. 1941. *Collection Henri Gaffié, Beaulieu-sur-Mer*

39

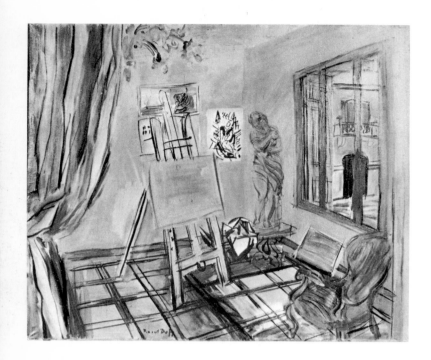

49. THE STUDIO. c. 1942. Oil on canvas, 18 ¼ × 21 ⅝".
Collection Mr. and Mrs. Charles S. Narins, Boston

is certainly in conflict with most trends in twentieth-century art. Nevertheless he was too kind and tolerant to condemn works opposed to his own; he had, for instance, a warm feeling for Chaim Soutine, both as man and artist, whose paintings are clearly depressive. Yet he objected to the "cruel malice" in Picasso's work, and to the "contempt for humanity" in Vlaminck's. His philosophy was closest to that of his friend Matisse, another painter of joy, who dreamt of "an art of balance, of purity and serenity, devoid of any troubling subject matter . . . like a good armchair in which to rest from fatigue."

Gustave Coquiot was neither condescending nor patronizing when he compared Dufy's works to the creations of a "milliner of genius who can give a twist to a ribbon or a feather that delights and holds the eye." On the other hand, the reviewer who remarked that he could hear the champagne glasses tinkling when he looked at

Dufy's pictures was not congratulating the artist. Some critics consider Dufy's art *passé* because it reflects a world of pleasure that barely survived the first World War only to go down in ignominy in the second. But this world still exists. It has moved from the boulevards of the urban centers to the "exclusive" suburbs. It survives in the *dachas* of prominent and influential East Europeans. It flourishes at receptions given by ambassadors the world over. Dufy's world thrived in the past and it will survive tomorrow.

Dufy, however, was no elitist. Asked to explain the role of art in life, he once said, "To render beauty accessible to all, by putting order into things and thought." This emphasis on order is typically Gallic—with "order" understood not as a Prussian propensity for subordinating everything to a rigid system, but rather as a Latin fondness for clarity of statement, for the logic inherent in form. Form—expressed in line, shape, color—is a creation of the mind which,

50. CHOPIN. 1950. Oil on canvas, 21 ¼ × 25 ⅝". *Collection Mr. and Mrs. Philip F. Vineberg, Montreal*

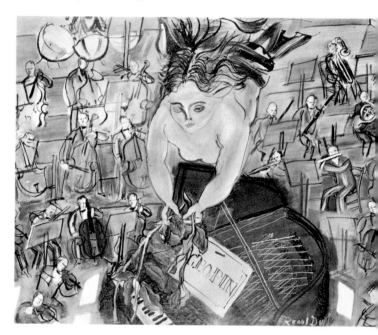

through simplification, rearrangement, and even omission of what is unessential or confusing, corrects the "mistakes" made by nature. Form increases beauty. Though all of Dufy's paintings are to some extent based on physical reality, the real Mediterranean is never so phosphorescently blue as the Mediterranean in his canvases. Dufy's brush endowed flowers, lawns, beaches, palm trees, and drawing room interiors with hues so fascinating and so various as to radiate an optimism without which man cannot hope to survive.

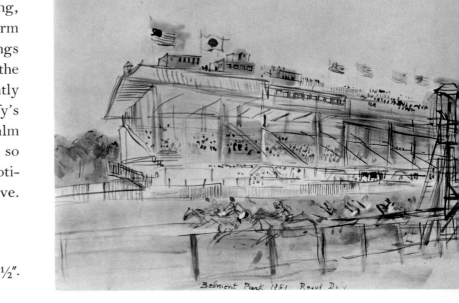

51. BELMONT PARK. 1951. Watercolor, 19 ½×25 ½".
Collection Mr. and Mrs. Dwight J. Thomson, Cincinnati

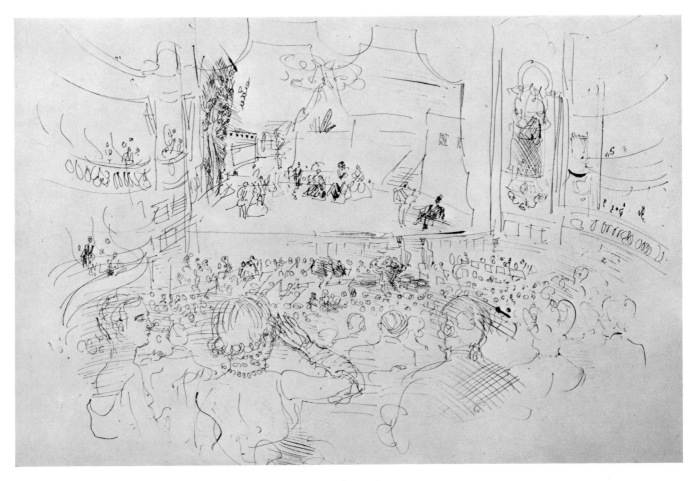

52. THE OPERA. 1952

BIOGRAPHICAL OUTLINE

1877 Birth of Raoul-Ernest-Joseph Dufy, at Le Havre, France, on June 3, eldest son of Léon-Marius Dufy, an accountant for a small metals firm, and his wife Marie-Eugénie-Ida, *née* Lemmonier.

1891 The family has hard time making ends meet and, at fourteen, Raoul Dufy leaves St. Joseph's *collège* (a grammar school) to take a clerk's job in the coffee-importing firm of Luthy & Hauser.

1892 Dufy enrolls at the Ecole Municipale des Beaux-Arts in Le Havre, studying in evening classes under Charles Lhuillier. At the school he meets Othon Friesz and Georges Braque.

1895–98 Paints self-portraits and portraits of members of his family. Admires paintings of Boudin in the Le Havre Museum, and Delacroix' *Justice of Trajan* in the museum in Rouen.

1898–99 Serves in the French army.

1900 The municipality of Le Havre grants him an annual scholarship of 1,200 francs, allowing him to go to Paris and study in Léon Bonnat's atelier at the Ecole des Beaux-Arts.

1901 Exhibits an oil, *End of Day at Le Havre* at the Salon des Artistes Français.

1902 Influenced by Monet and Pissarro, he paints Parisian scenes and Normandy beaches in a somewhat Impressionistic manner. A pastel is bought by Berthe Weill for thirty francs. He joins her gallery.

1903 He exhibits for the first time at the Salon des Indépendants where he will show repeatedly until 1936.

1905 Visits the "Cage of Wild Beasts" at the Salon d'Automne and is particularly enthralled by Matisse's *Luxe, Calme et Volupté*.

1906 Has his first one-man show (at Berthe Weill's gallery). For the first time represented in the Salon d'Automne. Works with Marquet at Trouville, with Friesz at Fécamp. As he stops painting Impressionist pictures, he is dropped by the dealer Blot.

1908 Works with Braque at L'Estaque near Marseilles, where he adopts a Cézannesque, near-Cubist manner.

1909 Accompanied by Friesz, he visits Munich.

1910 Friendship with several poets, among them Guillaume Apollinaire. Trip to the south of France. Stays with his wife at farm in Normandy, placed at the disposal of married artists by a philanthropist. Meets his colleagues Jean Marchand and André Lhôte. Interested in Poiret's Ecole Martine for decorative arts.

1911 Woodcuts for *Le Bestiaire, ou le cortège d'Orphée* by Guillaume Apollinaire.
The fashion designer, Paul Poiret, suggests that he execute woodcuts for textile printing. A printing shop is set up in Montmartre, Dufy supplying the designs.

1912 The large silk firm of Bianchini, Atuyer & Ferrier in Lyons asks him to become their art director on a fixed salary.

1913 Visit to the south of France—Marseilles, Avignon, Toulon, Hyères, and then to Venice.

1914 Second visit to Germany.

1915–19 Does many woodcuts, some on patriotic themes, for a variety of publications. Illustrations of books: *Poèmes légendaires de France et de Brabant*, by Emile Verhaeren (woodcuts, 1916), *Monsieur Croquant*, by Remy de Gourmont (watercolors, 1918), *Destinée*, by the Comtesse de Noailles (watercolors, 1919). Serves for several months

on the staff of the Musée de la Guerre.

1919 Contract with Bianchini, interrupted by the war, is resumed (to be ended in 1925).

Meets the poets Joaquim Gasquet and Paul Valéry.

1920 Book illustrations: *Des Pensées inédites*, by Remy de Gourmont (drawings, 1920), *Madrigaux*, by Stéphane Mallarmé (color lithographs, 1920).

1920–21 Long stay at Vence on the Riviera. Represented in the Salon des Artistes Décorateurs, Paris (1921). One-man show at the Galerie Bernheim-Jeune, Paris (1921).

1922–23 Travels to Florence, Rome, Sicily. *Friperies*, by Fernand Fleuret (color woodcuts, 1923). Exhibition at the Galerie le Centaure, Brussels. In 1923, begins collaboration with the Catalan potter, José Llorens Artigas.

1925 Journey to Morocco with Poiret. Fourteen tapestry hangings for Poiret's Seine barges (International Exhibition of the Decorative Arts, Paris).

1926 Set for the Comte de Beaumont's ballet, *Palm Beach* (Théâtre Châtelet). *Le Poète assassiné*, by Guillaume Apollinaire (color woodcuts, 1926).

1927 Begins decorations for the dining-room of Doctor Viard's villa.

1928 Publication of a monograph on Dufy, by Christian Zervos.

1930 Awarded Carnegie Prize for *L'Avenue du Bois*. Ambroise Vollard commissions him to do etchings for Eugène Montfort's novel of Marseilles, *La Belle Enfant*.

1931 Participates in the Prague exhibition of the School of Paris.

1932 The Musée de Luxembourg acquires its first painting by Dufy, *The Paddock at Deauville*, (now in the Musée National d'Art Moderne, Paris), presented by the Association des Amis des Artistes Vivants.

1934–35 Visit to England where he paints at Cowes and Ascot.

1936 Interested in the research of the chemist Jacques Maroger who discovers a "medium" which, by ridding pigments of their opacity, lets light strike through them. Dufy mixes this *"vernis Maroger"* with his oils. Illustrates with watercolors *Mon Docteur le Vin* for the Parisian wine firm of Nicolas. For the Compagnie Générale Transatlantique he makes designs for the decoration of the swimming pool of the liner *Normandie*. Commissioned to paint a large mural for the Palais de l'Electricité at the Paris World's Fair.

1937 Second visit to England, where he paints scenes from the coronation of George VI. Made officer of the Legion of Honor. Exhibition at the Petit Palais, Paris. Serving on the jury for the Carnegie Prize, he journeys to Pittsburgh. *Tartarin de Tarascon*, by Alphonse Daudet (color lithographs).

1938 Journey to Venice. Decorations for the Monkey House at the Jardin des Plantes, and for the theater of the Palais de Chaillot (both in Paris). Attacks of arthritis.

1939 Exhibition at the Reid and Lefebvre Gallery, London.

1940 Flees from the German invaders to the south of France, first to Nice, then to the Pyrenees (Céret and Perpignan). Executes two tapestry cartoons for the Aubusson factory. *Aphorismes* and *Variétés*, by Anthelme Brillat-Savarin (etchings).

1943 Exhibition at the Galerie Louis Carré, Paris (including his free version of Renoir's *Moulin de la Galette*). Large exhibition from Belgian collection at the Palais des Beaux-Arts, Brussels.

1944 Sets for Armand Salacrou's *Les Fiancés du Havre* at the Comédie-Française, Paris.

1945 Stay at Vence.

1947 Cartoons for tapestries, to be exhibited in 1948 at the Galerie Louis Carré.

1949 Stay in Spain, where he takes a cure at a spa. Large exhibition at the Louis Carré galleries in New York.

1950 Participation in the group exhibition "The Fauves," at the 25th Biennale in Venice. Journey to Boston where he undergoes cortisone treatment for his arthritis at the Jewish Memorial Hospital. Sets for production of Jean Anouilh's *Ring Around the Moon*. Exhibitions at Reid and Lefebvre Gallery, London, and at Perls Galleries, New York. *Pour un herbier*, by Colette (watercolors).

1951 After a prolonged stay in Tucson, Arizona, he returns to France. Monograph by Pierre Courthion.

1952 Lives at Forcalquier (Basses-Alpes). Goes to Venice for the 26th Biennale, where he wins first prize for painting (he divides the amount between two young painters). Largest exhibition of Dufy's work at the Musée d'Art et d'Histoire, Geneva.

1953 Exhibition at the Ny Carlsberg Glyptotek, Copenhagen. Dies of a heart attack at Forcalquier on March 23. Buried in Nice at the cemetery of the monastery of Cimiez. Memorial exhibition at the Musée d'Art Moderne, Paris.

DRAWINGS

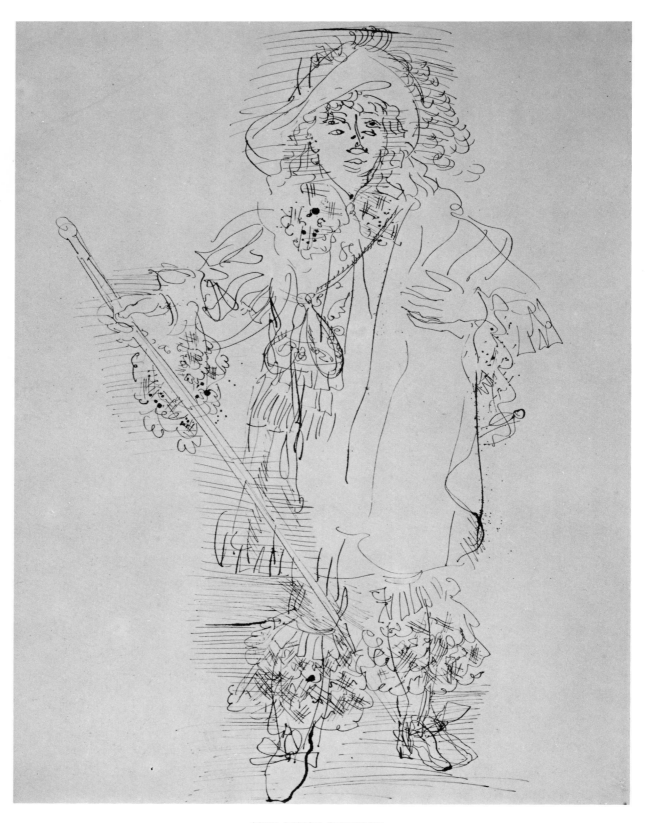

53. THE ACTOR DEHELLY. 1935

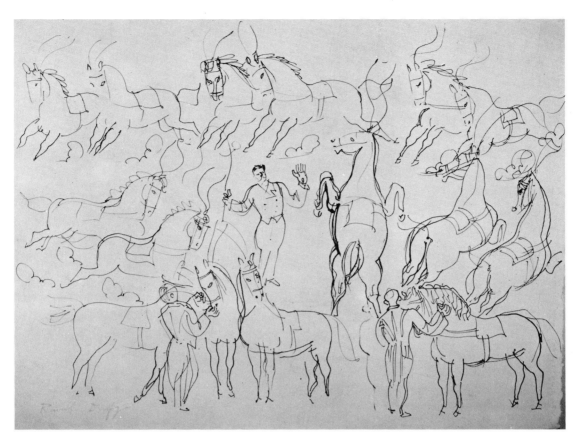

54. CIRCUS HORSES. 1931. Ink, 19½ × 25½″. *Private collection, France*

55. EPSOM. 1934

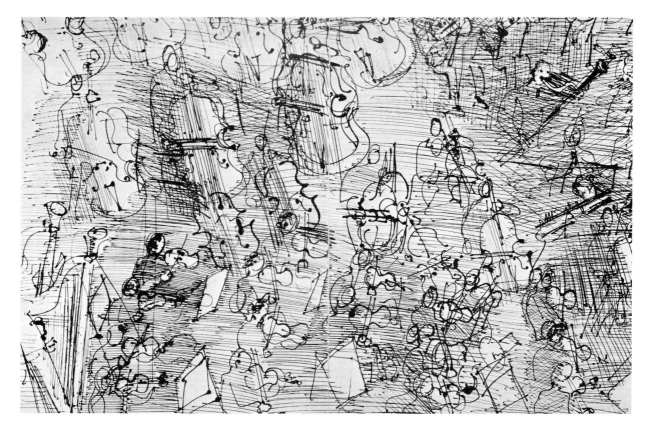

56. ORCHESTRA. 1936

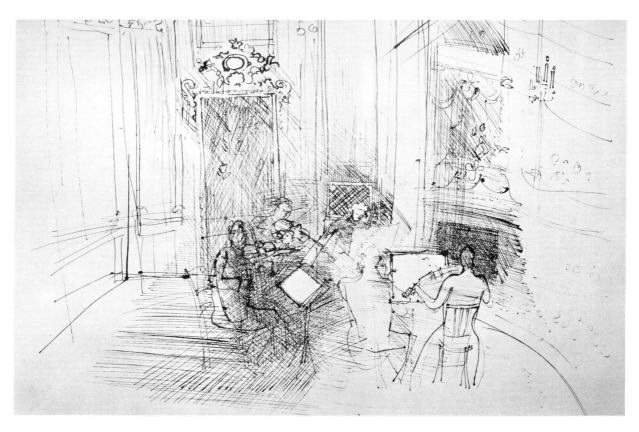

57. ANCIENT INSTRUMENTS. 1939

COLORPLATES

Painted about 1902

LANDSCAPE AT FALAISE

Oil on canvas, 31½ × 25″

Collection Jerome A. Newman, New York

The town of Falaise is the gateway to *la Suisse Normande*—the Switzerland of Normandy—an area south of Caen noted for the charm of its hills and valleys, woods and rivers, walled apple orchards and green meadows. Parisians who want a peaceful rural interval often take their vacations in this area.

This picture is still "realistic" in the manner of Monet and Pissarro, whom the young Dufy had discovered for himself upon his arrival in Paris from Le Havre. But this landscape also indicates that he may have been exposed to the experiments of the Nabis—Maurice Denis, Pierre Bonnard, Edouard Vuillard, and others—who in the 1890s had introduced the concept that nature was no more than raw material for the artist to organize in order to translate his mental image into a composition. The proponents of this aesthetic maintained that works of art were chiefly metaphors to express feelings.

Even if he so desired, young Dufy was still too timid to paint a tree red. That freedom was to come a few years later through his exposure to the work of Matisse. In this painting, objects still have their "natural" colors, and they cast traditional shadows. Yet the greens and blues are flatter than those in strictly Impressionist pictures, and thus anticipate Fauvism. The trees form a decorative tapestry-like pattern reminiscent of Art Nouveau, and the playfully applied dots, which represent leaves, forecast the imaginative and utterly free calligraphy of the mature and highly original Dufy.

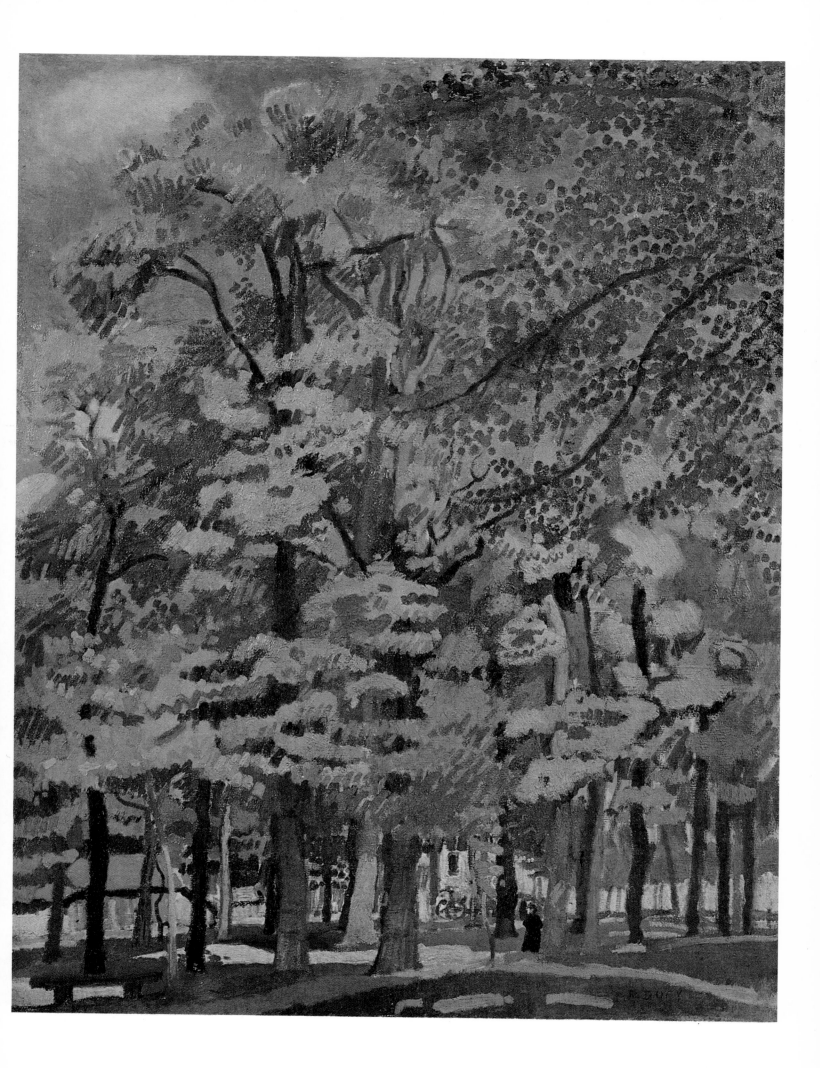

Painted in 1904

BEACH AT SAINTE-ADRESSE

Oil on canvas, 25⅝ × 31⅞"

Musée National d'Art Moderne, Paris

Sainte-Adresse, the "Nice of Le Havre," is a seaside resort a few miles northwest of that port city, and accessible by tram. The resort is full of memories for many older Americans—one building half-way up the hill dominating the town was an American Expeditionary Forces headquarters during World War I. Historians of art know Sainte-Adresse as a favorite subject of young Monet. This particular picture, however, evokes not only the Impressionists, but also one of their immediate predecessors, Eugène Boudin (1824–1898) who, like Dufy, was born on the coast of the English Channel (in Honfleur). Indeed, the format as well as the motif of this painting recalls the numerous pictures of fashionable beaches, thronged with crinolined ladies and their escorts, that were Boudin's specialty.

Bathing costumes and customs may have been much the same in 1904 as they had been decades earlier in Boudin's time, but styles of painting had definitely changed. For Boudin, the windswept clothes of the ladies served as lively color accents to offset the prevailing brown. In this oil, however, which marks the end, or near-end, of Dufy's Impressionist period, all is suffused with light. Spots of white accent the black and brown garments of the figures, and notes of red, green, and purple sparkle here and there. The painting style is strictly Impressionist in its free and spontaneous reduction of form to color spots of different sizes. But while the Impressionists often neglected design, Dufy, by contrast, has selected a vantage point that focuses sharply on the pattern of the pier and thereby gives formal strength to an otherwise soft and fleeting phenomenon.

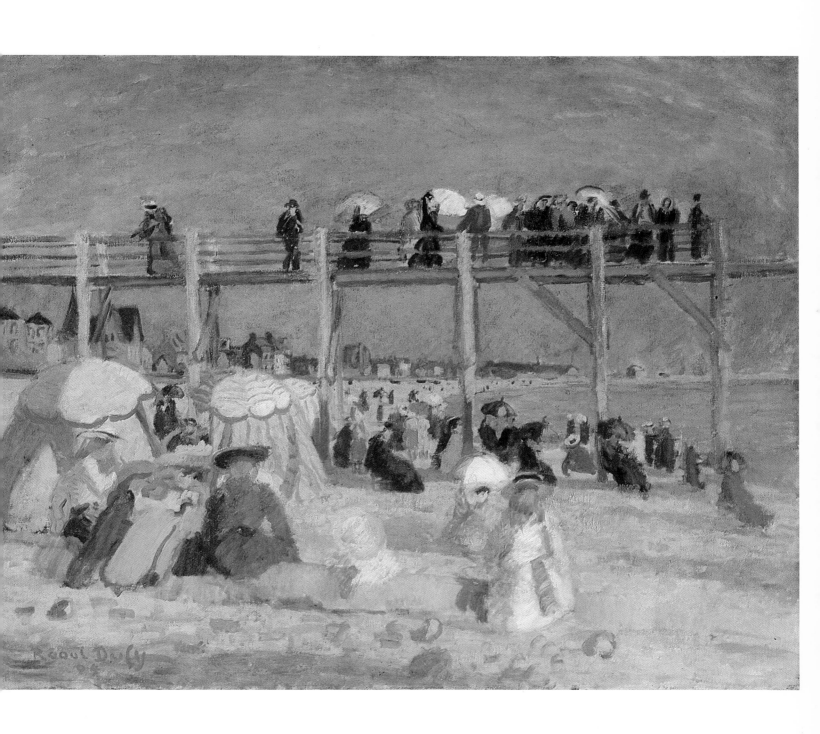

Painted in 1905–6

THE PORT OF LE HAVRE

Oil on canvas, 24 × 28¾"

Art Gallery of Ontario, Toronto. Gift from the Women's Committee Fund, 1953

In 1889, the newspaper *Gil Blas* carried an item about Dufy's native city: "Along the poetic coast, Le Havre is a new town, an accident of heaped-up iron and stone, an American town, with no past and no artistic tradition. One would think that its inhabitants have not the leisure to contemplate the admirable setting in which they live. But if by chance one of these men of Le Havre who walk with their eyes fixed to the ground takes it into his head to look up, then he is touched by grace. His artistic vocation proves all the more rare for the lack of example from his fellow-men: it is nature which has called him."

Young Dufy was among the few who "looked up." To the sensitive eye of the painter, the colorful and bustling docks of Le Havre offered much visual excitement. When he painted *The Port of Le Havre*, he had already fallen under the spell of Matisse. He was about to become a Fauve—witness the heavy strokes, and broad patches of pure color skillfully played one against another. The color dabs and patches, each fully expressive and self-assertive, vary in shape and thickness. By their bold juxtaposition, these colors take on a great intensity of light, heightening their effect considerably. But the strong impact of Fauvism is not yet completely there. On the other hand, the playfulness in the shimmering reflection of boats and houses in the water anticipates the Dufyesque style of the 1920s.

In the lower left corner one can read: "*Reconnaissance et sympathie au Docteur Maze—Raoul Dufy.*" Judging by the handwriting, this dedication is from the 1930s.

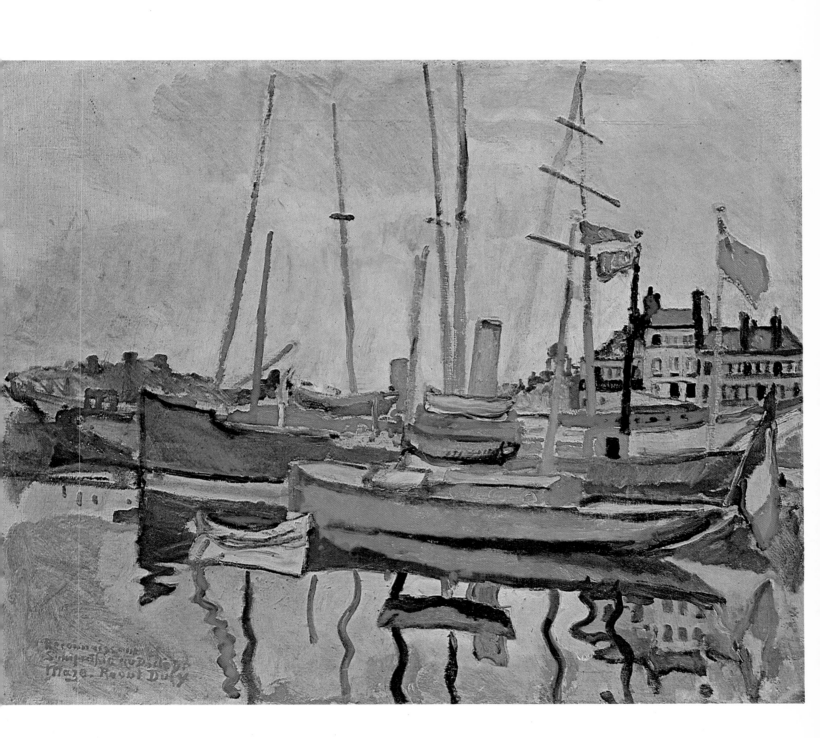

Painted in 1906

POSTERS AT TROUVILLE

Oil on canvas, 25⅝ × 34⅝″

Musée National d'Art Moderne, Paris

In this picture, Dufy may have been attracted to the poster-covered fence somewhat in the same way American Pop artists of the 1960s turned their attention to the commercialism of thoroughfares and highways. By exploiting the visual vehemence of these posters, the Fauve Dufy succeeded in transfiguring their avalanche of vulgarity. Constable once asserted that he had never seen anything he considered ugly and that, moreover, artists had the power to make any object seem attractive. Suzanne Valadon, when asked by her son, the painter Maurice Utrillo, whether she thought one of his oils ugly, replied reassuringly, "It can't be ugly enough!" Her answer expressed her scorn for all the *faiseurs de beauté* nurtured by the academies. One may note a similarity between Utrillo's pictures, in which shop signs and advertisements are prominent, and this painting by Dufy.

Here the colors are strong, the outlines firm. The passing holiday-makers are depicted whimsically, almost as flat shadows cast on the ground, but curiously, the shadows that *they* cast are treated almost like halos, in rich glowing reds, golds, and yellows around the legs and feet of the figures. Without these bright spots of color, the sand on which they are walking is hardly distinguishable from the sky. Nothing perhaps but the folding chair at the lower right suggests that the scene represents a corner of a famous resort on the English Channel.

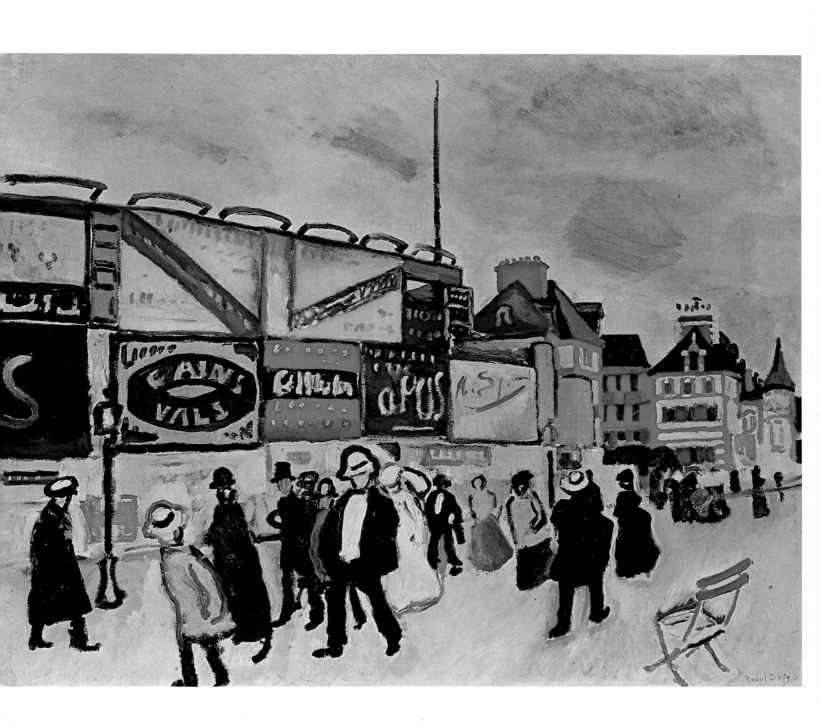

Painted in 1906

WINDOW WITH COLORED PANES

Oil on canvas, 32 × 25½″

Collection Mr. and Mrs. Crawford A. Black, New York

By and large, the Fauves sought to create strong, firm design, in opposition to the Impressionists who, whatever they painted, eventually dissolved all objects into dazzling miracles of atmospheric shimmer. Here one finds none of the loose construction, none of the color play, that Dufy himself had made use of in his "Impressionist" period. Instead he exploits the strength of the framework and leading of the window, and the brilliance of the glass panes.

The view is part of the entrance hall of a nineteenth-century mansion. The artist is obviously fascinated by the geometric pattern of the windows and their frames. The rigidity of this central motif is slightly softened by the delicate leafy plants at the lower left. Dufy emphasizes his vertical composition by including the strong, firmly placed newel post that appears at the foot of the balustrade and indicates the beginning of a staircase. Note that the landscape outside cannot be clearly discerned, although the central parts of the panes are transparent.

This picture, incidentally, conjures up memories of Utrillo's "White Period," especially his *Factories*, with their strictly two-dimensional arrangement of solid-color rectangles. Both Utrillo and Dufy are essentially making a geometric statement.

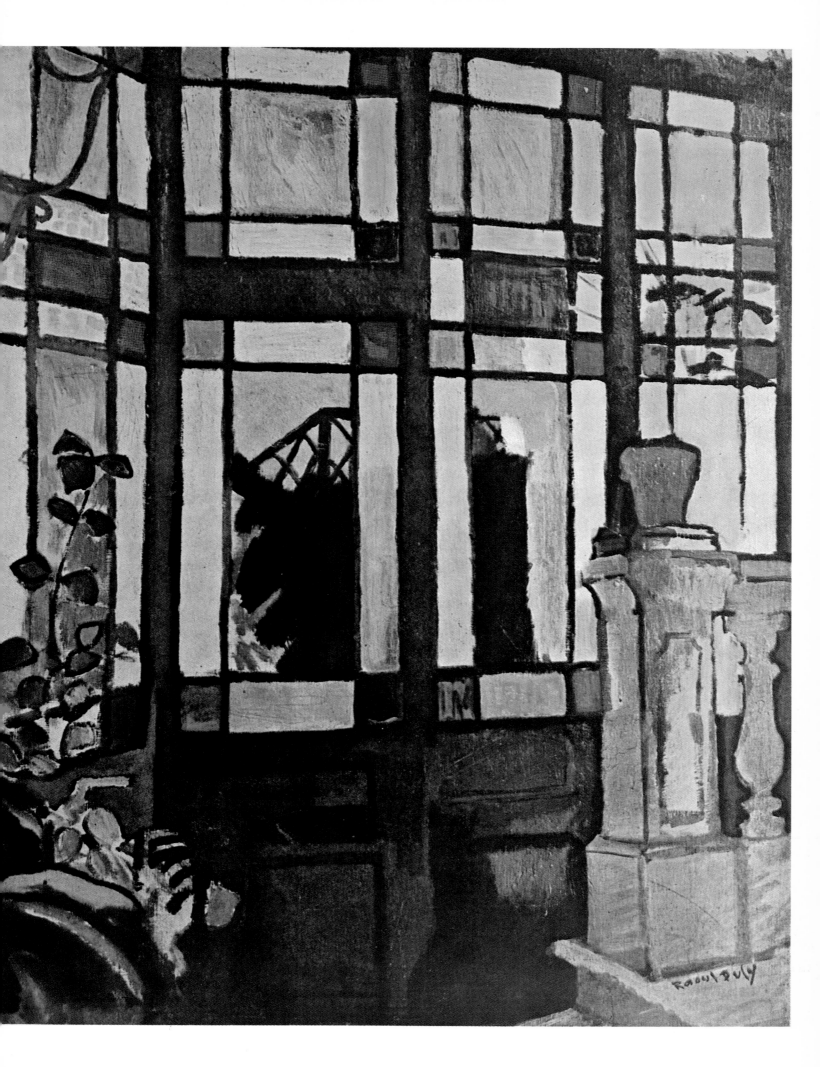

Painted in 1908

FISHERMEN WITH LINES

Oil on canvas, 25⅝ × 31⅞"

Collection Jean-Pierre Moneix, Libourne, France

This scene of fishermen and idle onlookers is an amusing one. Though their faces are either turned away toward the sea or schematized in profile, the figures are nevertheless individualized by a few clever details of stance. A holiday mood prevails. This picture is mild and soft. Gone are the "wild" colors of Dufy's earlier Fauve experiments. This change in Dufy's palette may have been influenced by Braque, who had also abandoned Fauve chromatics and reverted to a low-toned palette, emphasizing greens, grays, and tans. One may also recall that Dufy, tired of the color explosions of the "Wild Beasts," had turned with others to Cézanne for fresh inspiration.

Notice the marked simplification of this composition in comparison to the *Window with Colored Panes*. Here the picture is divided into three sharply defined, horizontal bands of color representing sky, sea, and land. The high horizon line (a device borrowed from the Japanese) and the relatively narrow land area entrust most of the space to the middle distance, an area devoid, except for the pleasant tonal gradations, of visual interest. Yet the composition is solidly unified, pulled together by the fishing poles which rhythmically reach out toward a focal point, span the empty space, and connect with the sailboats at the horizon. The figures at the rail, rhythmically rendered and placed, create a feeling of movement, bringing life to an otherwise still scene. Dividing the picture area into three parts—either horizontally or vertically—is a favorite compositional device of the artist.

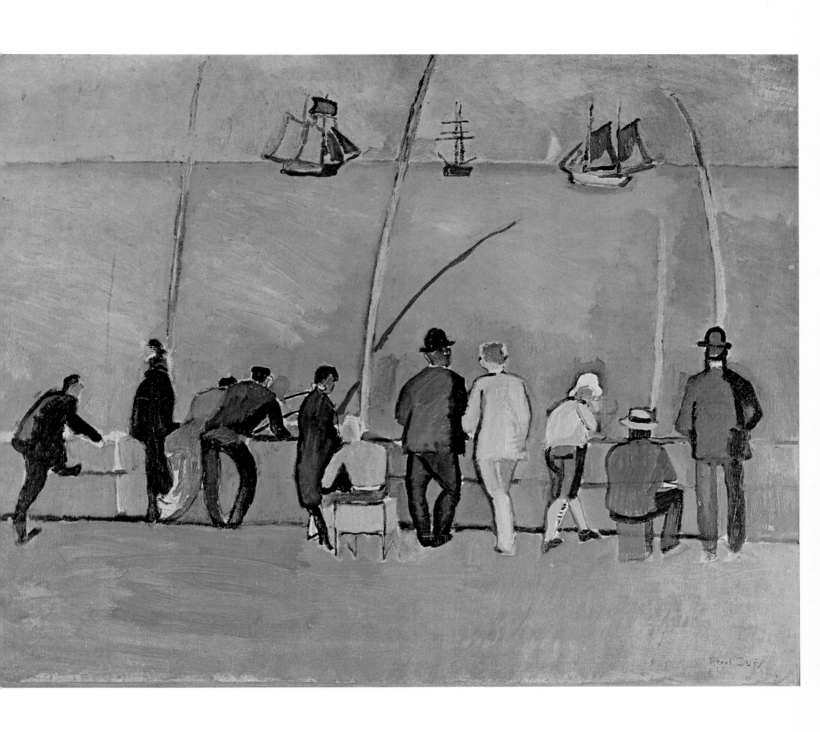

Painted in 1908

WOMAN IN PINK

Oil on canvas, 31 ⅞ × 21 ⅝"

Musée National d'Art Moderne, Paris

During his Fauve period, Dufy had little interest in the human figure; he returned to it under Cézanne's influence. One is reminded of Van Gogh's portraits and self-portraits produced in 1888 and 1889, of Modigliani's work (seven years younger, Modigliani painted portraits similar to this one, but not before 1915), while the simplicity of form, the feeling of roundness, also recall Matisse.

The confines of the room are barely indicated by the suggestion of a door (to the left), by a small orange triangle that represents the floor space, and by the almost indiscernible arm of a sofa (to the right). The "wall" is actually a continuation of the green sofa, from which it asserts itself by short, rhythmically placed black and orange lines arranged in a short sunburst design.

While the sitter's identity is unknown, her character is rather sharply defined—despite the somewhat abstract fashion in which Dufy has rendered her likeness. Note the exaggerated size of the slanted eyes and the uninterrupted, elegant line defining the outline of nose and eyebrow. There is something melancholy and dreamy about the woman's face. Her undulating hands, with their elongated, boneless fingers, strike a pose that is the focal point of the picture. Her left arm, composed of two curves, is anatomically "incorrect," as are the hands. The pink dress hides rather than delineates her figure. Nevertheless, the underlying form, though not rendered in detail, asserts itself with a rather impressive sculptural strength.

One is inclined to think that this wistful and very feminine sitter is Oriental, judging by the yellow skin tones and the Japanese style of the coiffure.

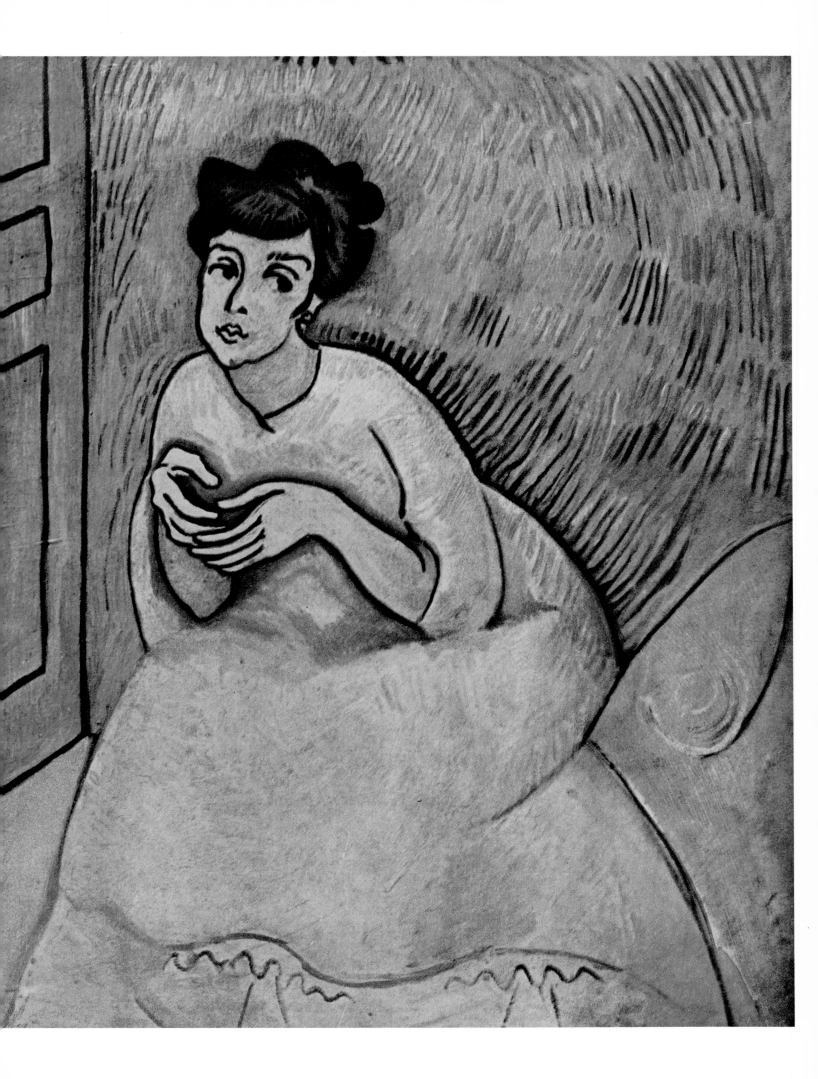

Painted in 1909

STANDING NUDE

Oil on canvas, 32 × 25⅝″

Collection Henri Gaffié, Beaulieu-sur-Mer

This muscular, stocky nude is closer in treatment to Braque's *Bather* than it is to Picasso's bizarre and dramatic *Demoiselles d'Avignon* (The Museum of Modern Art, New York, 1907). Still, Dufy's *Standing Nude* is clearly of the twentieth century, "ugly" and expressive, even though it was painted at a time when conservative artists continued to depict the naked female as a Venus, an Amazon, odalisque, courtesan, or simply a *bourgeoise* taken by surprise in an intimate pose. Few of his contemporaries would have dared to simplify the subject even as much as Dufy does for the sake of greater expression. Yet in 1909 Dufy was at the height of his Cézann-esque period, having taken to heart the parting message of the Master of Aix to "treat nature by the cylinder, the sphere and the cone."

The angularity and studied deformation (especially in the face), and the emphasis on structure and rhythm rather than on naturalistic accuracy clearly separate this picture from the frankly sexual approach of a Renoir. Dufy never went so far as Braque or Picasso in faceting and fragmenting his forms. Still, while he never did and never could have produced figures as startling and bewildering as Picasso's large-nosed, double-faced female, neither did he settle for the merely pretty or pleasing—one would look in vain through Dufy's entire *oeuvre* for a figure resembling a fashion photo-grapher's stylish rendering of a woman.

In Dufy's later pictures, the setting is never so austere as it is here. Generally the model is shown in a real room filled with furniture, pictures, and often the artist's studio equipment.

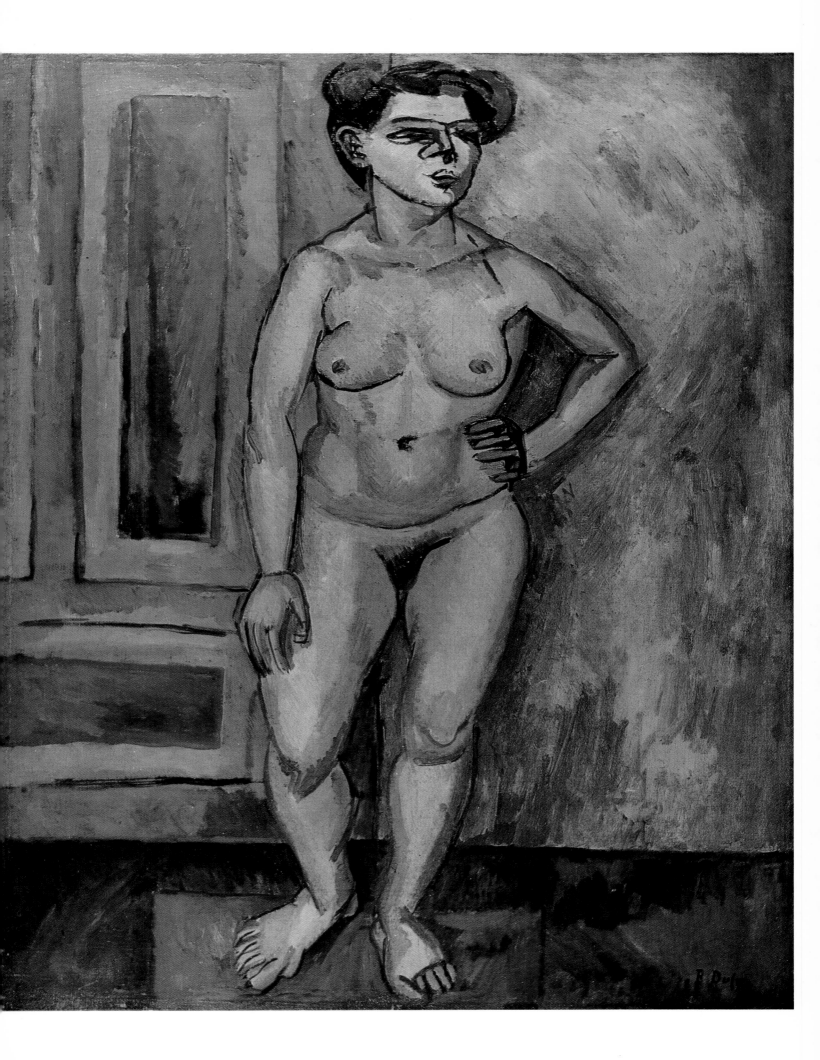

Painted in 1912

SAILBOAT AT SAINTE-ADRESSE

Oil on canvas, 34⅞ × 45⅝″

The Museum of Modern Art, New York. Gift of Mr. and Mrs. Peter A. Rübel

Eight years had elapsed since Dufy painted the *Beach at Sainte-Adresse*. At the time, he had been a Fauve; after the Fauvist interlude, he became interested in Cézanne's and the Cubists' theories and techniques. Had he painted this particular panorama in 1904, he would have produced a picture stylistically not significantly different from Monet's painting of the same motif done in the late 1860s. In his own *Beach at Sainte-Adresse* (The Art Institute of Chicago), Monet tried to perceive objects photographically. In a manner that anticipated the mature Impressionism of the mid-seventies, he carefully defined each compositional element with descriptive detail— the sandy beach peopled with fishermen and their rowboats, the town in the background, the Channel with sailboats, and the vast expanse of the sky.

In this picture, however, Dufy deals with topography only in the most cursory and general manner. Except for the rather Mediterranean white pavilion in the center, the houses have strangely Gothic features. The boat, tilted on its side by the wind, looks like a toy. Gone is the Impressionists' desire to recreate fluctuating light and airy atmosphere. Here we have more of a journey into the realm of fancy than a realistic rendition of a Norman coastal town. The fascination with bold, often rather arbitrary colors anticipates the Dufy of the twenties and thirties.

Though this is essentially a horizontal composition (and unusually tense and tight at that) divided into three planes, the artist unifies the picture in two ways—by placing the boat and the yellow fishing rod so that they extend from the foreground and thrust into the middle distance, and by his judicious use of white in each of the three planes. Both devices lead the viewer's eye from the edge into the focal point of the composition, the white pavilion.

At the lower edge of the picture, note the angler at the end of the blue balustrade; the curved forms at the right suggest boats lying in low tide. Very Dufyesque is the fish-scale pattern in the water suggesting waves.

64

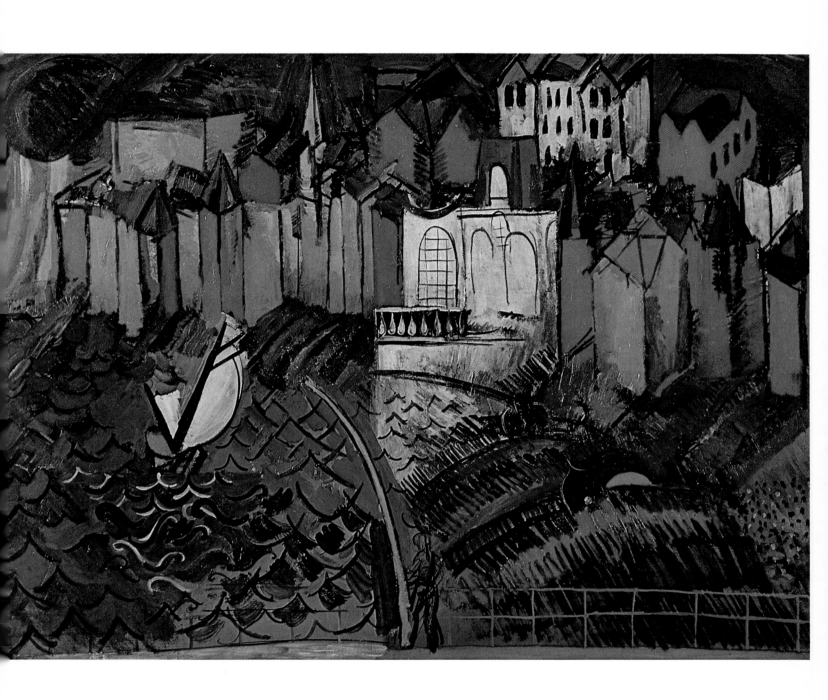

Painted in 1914

NEAPOLITAN FISHERMAN

Oil on canvas, 29⅛ × 15¾″

Perls Galleries, New York

The geometric patterns of the figure and particularly its fragmented and faceted face indicate that Dufy was still under the spell of Cubism when he painted this *Neapolitan Fisherman*. However, he did not become a radical, full-fledged Cubist, just as he was never either an orthodox Impressionist or a really committed Fauve. In his quasi-Cubist period, Dufy did not carry geometrical abstraction to the point of making the object unrecognizable; he always retained a suggestion of three-dimensionality. Moreover, he used his own vivid colors even when most Cubists restricted themselves to austere monochromes of pale grays or browns. This was a period in which he tried, not entirely successfully, to "reconcile the natural grace of his irrepressible fantasy with the demands of rules to which he conformed," as one of his biographers, Marcelle Berr de Turique, has stated.

This fisherman, in his colorful native costume, somewhat resembles a pirate—perhaps on account of the rings in his ears. In the same period, Dufy painted several pictures of gardeners carrying their produce to the market. This particular denizen of Naples is holding a basket with a large fish. In the upper right corner is a little sailboat with a red hull.

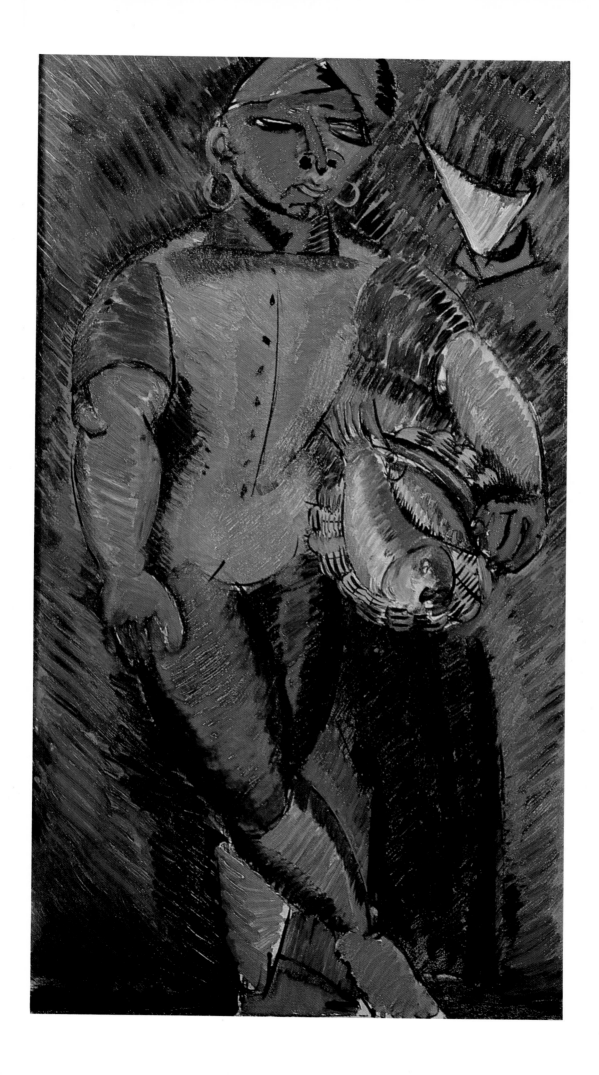

Painted in 1914

BIRD CAGE

Watercolor, 24⅜ × 19¼"

Private collection, Paris

The subject of birds in cages is one not frequently treated in Western art. Yet it occurs repeatedly in Dufy's *oeuvre*. The present picture is interesting for its demonstration of how Dufy, despite his early parting from Georges Braque, developed in a manner that occasionally brought him close to the aims of the Cubists. By 1914, Picasso and his associates had abandoned Analytical Cubism (which faceted and fragmented reality); their Synthetic Cubism reconstructed reality even if it often made use of heterogeneous and seemingly unrelated matter. The early austerity and angularity had been laid aside, and some of the phenomena of the "Rococo Cubism" of 1914, with its gaiety and curvaciousness, even vaguely resemble what Dufy was trying to do independently.

Unlike Picasso and Braque, however, Dufy did not make collages. A striking detail, however, that can also be found in 1914 works by both Picasso and Braque, are the decorative white dots in the blue triangle above the bird cage, echoed by the blue dots in the adjoining area. Of all the pictures in this book, this is the one in which the artist is least concerned with the accurate rendering of reality. Three-dimensionality is barely indicated through a very loose application of perspective. The bird's shape may be accurate, but it is ruthlessly divided into white and dark blue halves, for purely aesthetic reasons. The preponderance of cool colors harks back to Dufy's Cézannesque period instead of foreshadowing the chromatic joyfulness he was to develop after World War I. In 1914, a picture like this must have shocked many. Paraphrasing Matisse, Dufy might have retorted to the accusation, "I have never seen a bird cage like that!" with the reply, "But this is not a bird cage, this is a painting!"

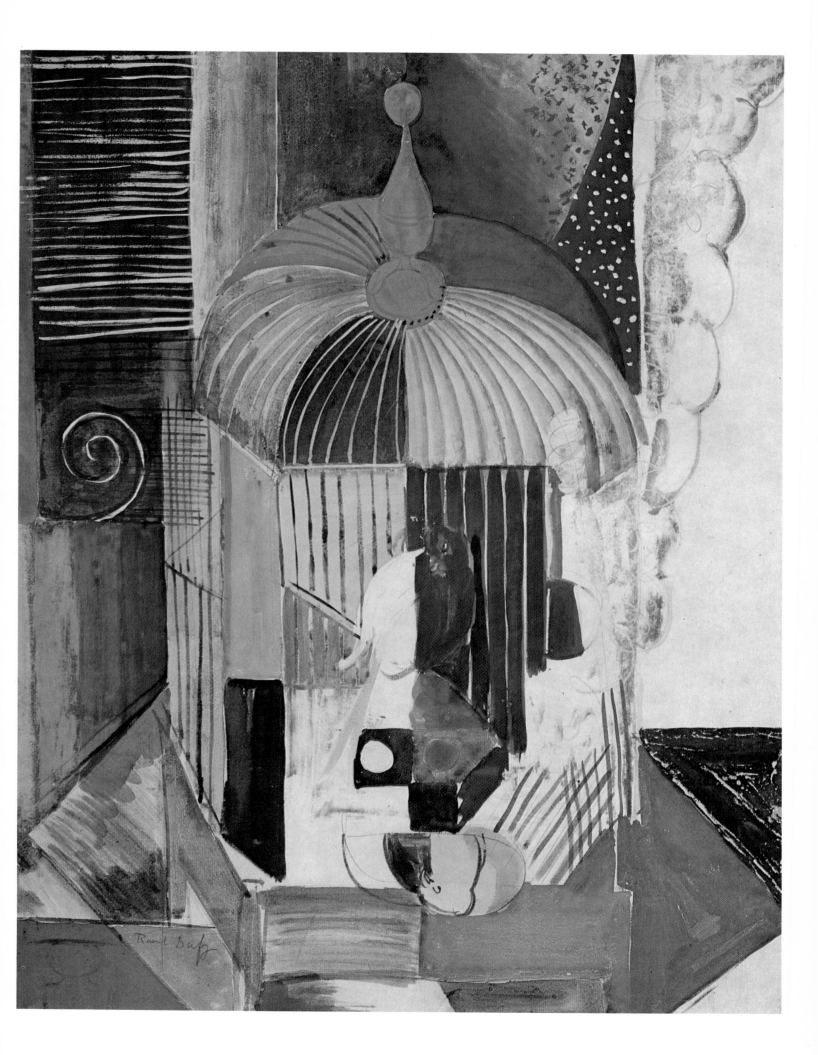

Painted in 1922

ACROBATS

Gouache, 25¾ × 19¼″

Collection Mr. and Mrs. Irving Mitchell Felt, New York

The circus has been a favorite theme with many artists—the names of Degas, Toulouse-Lautrec, Beckmann, and Chagall come quickly to mind. However, there are not many circus pictures by Dufy. Here, the tight-rope walkers use large parasols to help keep their balance. An exciting pattern is produced by these parasols (compare Renoir's famous picture, *The Umbrellas*, in the National Gallery of Art, London). Typically for Dufy, the red of the tights, and the bluish-black of the man's suit spill out beyond the borders of the figures, creating a kind of aura around them. Mark the strange abstract pattern at the bottom (perhaps indicative of the net?), and also the thinly sketched bicycle, to be used in another act.

This picture is painted in gouache, or opaque watercolors, but its unusual lightness and airiness is due to the fact that here the medium is used in transparent washes like regular watercolor. The artist also availed himself of pen and ink to outline the figures, and to draw the bicycle. The delicacy and fluidity of the pen line contribute to the feeling of action, movement, and lightness. The mixture of mediums chosen by Dufy is perfect for the precarious subject he is painting.

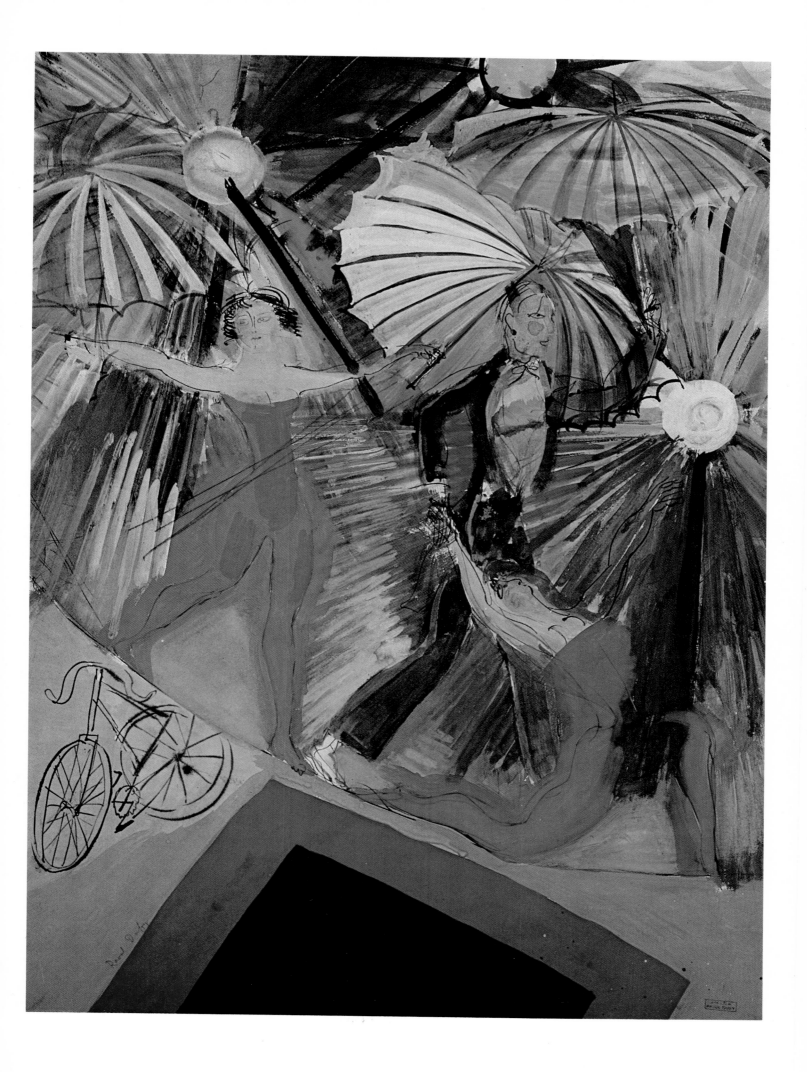

THE MEDITERRANEAN

Oil on canvas, 50¾ × 43¼″

Collection Mrs. Louis S. Gimbel, Jr., New York

From his early childhood, Dufy loved the sea, which indeed formed his daily horizon. Throughout his life, the sea offered an inexhaustible source of inspiration. Yet unlike the celebrated seventeenth-century Dutch marine painters, or the Englishman Turner, he took little interest in seascapes for their own sake. For him it was a playground, replete with shells, pagan deities, fish, swimmers, and curious ships and boats of all kinds. As a young man he knew only the grayish-blue of the Channel, beneath an often cloudy or rainy sky.

On a trip to southern France, Dufy discovered the deep cobalt blue of both sea and sky in the Mediterranean climate. Although the Côte d'Azur becomes luminous blue only on days of complete calm, this mattered little for Dufy's purpose, which was to create a symphony in blue.

Indeed, more or less the same color is used for beach, ocean, and sky, with only a slight attempt to divide them. This approach is not an innovation for Dufy, for the artist frequently liked to create huge areas of a single color and invent an imaginary perspective that would bring even the most distant objects of the picture clearly into focus. Mention must also be made of his use of red and white. Without these color spots, the painting would be somewhat gloomy, and certainly undefined, despite the intensity and richness of the blue. The bright red used to render the figures of the bathers and the swimmer, and to highlight the white boat on the horizon, brings the presence of fiery sunlight to the canvas, as though its intensity had been absorbed and then reflected onto the surroundings. The spots of white —clouds, boat at the horizon, towels in the foreground—contribute to the sparkle of sun and sea at midday. Without this white, the picture would be less dazzling.

As for Dufy's imaginary perspective, the artist in this picture boldly defies the laws of color perspective. There is no lightening of values as the picture recedes toward the horizon. On the contrary, the white of the clouds is brighter than the white of the towels, and the red color spots on the boat at the horizon are as bright as the red foreground figures. Where the tones and gradations fall is not determined by how near or how far away they are, but rather by their design interest.

In *The Mediterranean*, Dufy nearly outdoes nature with his deep blue of an unsurpassed sensuous quality, a blue that, to borrow a phrase from medieval theology, is not a color but a mystery. No modern artist, with the possible exceptions of Matisse and Chagall, has used a blue so intense and, at the same time, so warm.

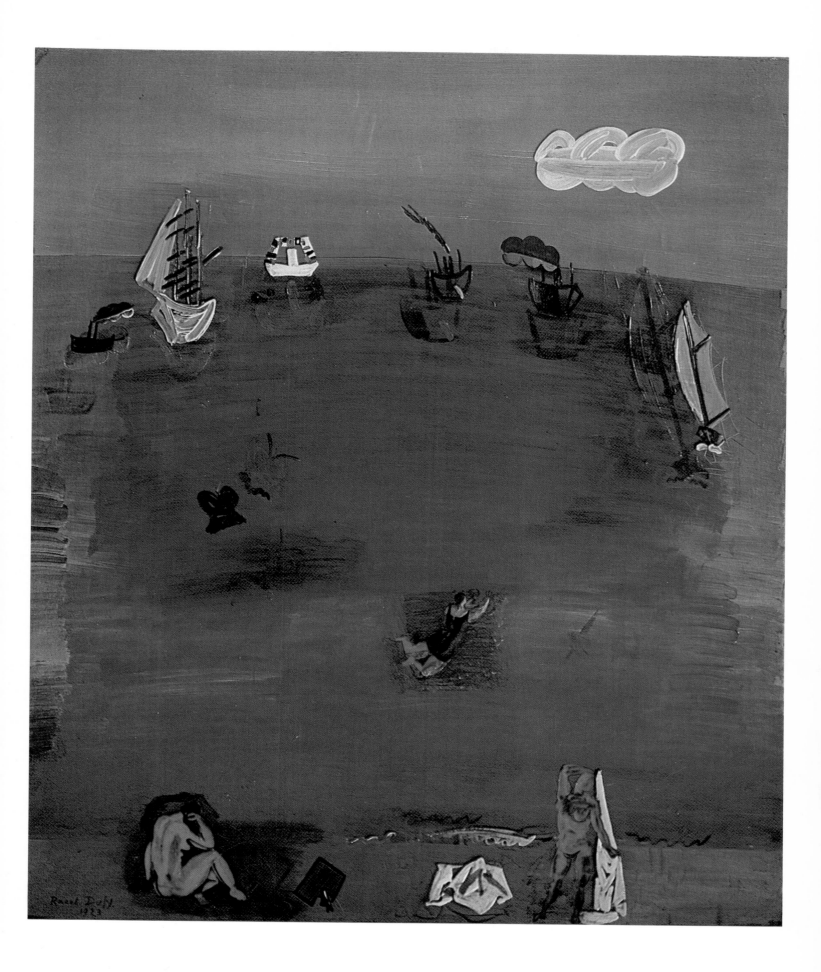

Painted in 1923

VENCE

Oil on canvas, 31 ⅞ × 39⅜″

Musée Massena, Nice

In the early 1920s, Dufy painted many views of Vence, that old hill-town near Nice, so beloved by writers and artists. D. H. Lawrence spent the last few weeks of his life there; Matisse went to Vence in search of health and, as a tribute to the Dominican nuns who nursed him, designed and decorated his famous chapel; Chagall, on his return from his World War II exile in the United States, took up residence in Vence and is currently living nearby.

Here one can recognize certain well-known features of the town—the ramparts, and in the center the tower, which also dominates Chagall's many renderings of the scene. This is the view one sees when approaching the town from the coast. Although the composition is tighter and denser than the artist's work of the thirties and forties, this picture nevertheless bears the unique stamp of Dufy—the rippling arabesques, the variety of flat color patterns, the original calligraphic brushwork. These elements, along with the very Dufyesque tiled roofs, olive trees, and scallop-like clouds, combine to heighten the decorative charm of the picture.

Note how the more remote elements in the background are enlarged in defiance of traditional aerial perspective. In its delightful fantasy, this picture could well be the backdrop for an opera. But despite all its stylistic liberties, and its emphasis on rhythm rather than space or weight, Dufy's painting miraculously retains the flavor of the real Vence.

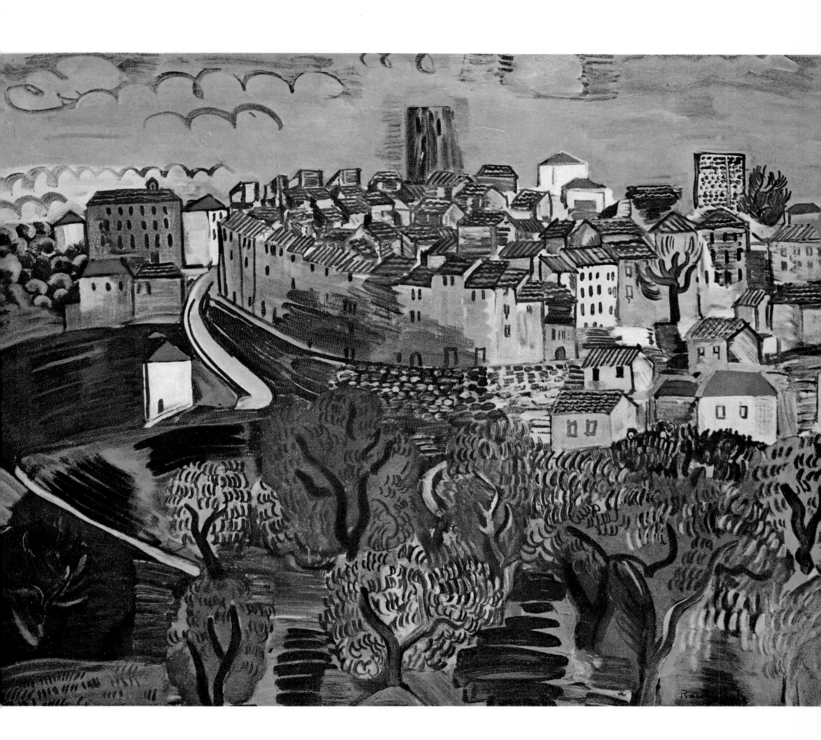

Painted in 1924

PARK OF SAINT-CLOUD

Oil on canvas, 28⅝ × 23⅝"

Musée de Peinture et de Sculpture, Grenoble

Saint-Cloud rises from an amphitheatre on the left bank of the Seine, to the northwest of Paris. Its large park, which belonged to a Louis XIV château that burned down in 1870, extends over the hills southwest of the city. The gravel path in the foreground of the picture leads to a balustrade, below which flows the Seine.

Dufy's desire, however, is not to give an accurate description of what can be glimpsed by the tourist. There is nothing static about this view—Dufy makes the houses undulate like ocean waves, and his characteristic shorthand calligraphy puts life even into the statues on the extreme right and into the urns of flowers along the path taking us to the celebrated lookout.

Note the picture's tunnel composition. It is based on a playful tension between vertical and horizontal rectangles. The tunnel itself is formed by the trees rising vertically at the picture borders and arching slightly toward the center to meet the sky, which is composed of horizontal rectangles to form a flat vault. The statuary on the right, the central rows of urns and the path which they divide, and the patches of grass and gravel on the left, are all rectangular forms very consciously and cleverly placed to lead the viewer's eye through the tunnel and out into the middle distance. The foreground and sky are designed to compress the focal point of the picture into the narrow horizontal band of urban buildings that rises just beyond the balustrade. This is also where the light falls, illuminating the colors and clarifying the details of the forms. Dufy's use of light and dark harmonizes with the placing of forms, and adds enormously to the feeling of space. The foreground begins in shadow and gradually lightens as it approaches the focal point; the composition sharply darkens just above the buildings, loses its detail, and diminishes in color intensity.

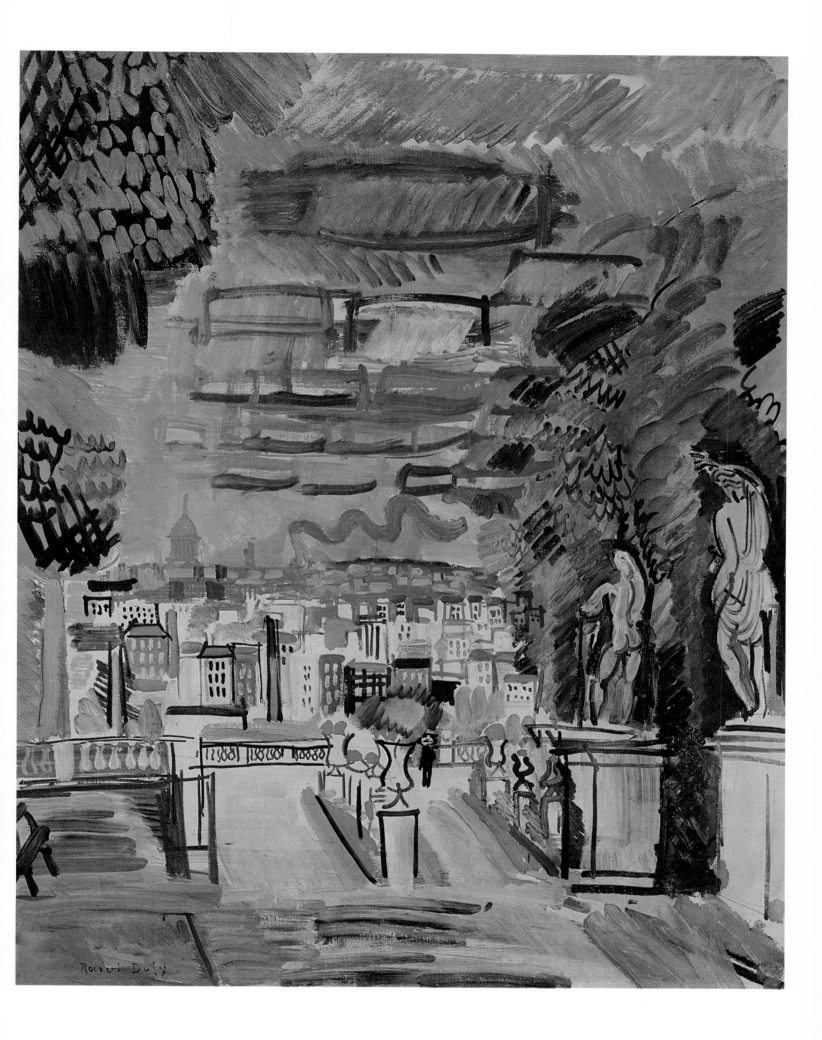

Painted in 1925

OARSMEN ON THE MARNE

Oil on canvas, 23⅝ × 28⅝"

Collection Mrs. Louis S. Gimbel, Jr., New York

In the late nineteenth century, the Impressionists, who loved boating, often painted this subject in their characteristic style, combining realism with the interplay of light and air. But Dufy was no Monet, no Caillebotte, no Renoir. This picture might very well serve as a backdrop for a ballet or musical comedy. The figures are as carefully postured in their movements as dancers. In the gingerbread summer house, Dufy evokes every detail, yet hardly any detail can be seen clearly. While the predominant colors are variations of green playing against a soft blue, spots of bright red in the central door, the blue coat on the bench, the area of rose pink in front of the house, and the yellow on the left boat add lively accents. So strictly arbitrary are the colors in this pale dream picture that the waters of the Marne are painted both in the green of a lawn, and, toward the right edge, in the soft blue of a sky.

Considering the fact that Dufy's medium is oil, the feeling of limpidity and transparency is quite extraordinary. The picture has all the qualities of evanescence and spontaneity, as well as limpid light, that one expects only in a watercolor. To achieve all of this, Dufy outlined the forms in black over a colored ground, then left the object or figure blank so that the colored ground shows through (see the roof of the house, all the figures, the oar, the bench, the boat in the right corner, the jetty on the left). Also, he uses white the way an aquarellist would use the untouched paper, letting it show through to give sparkle and luminosity to the painting.

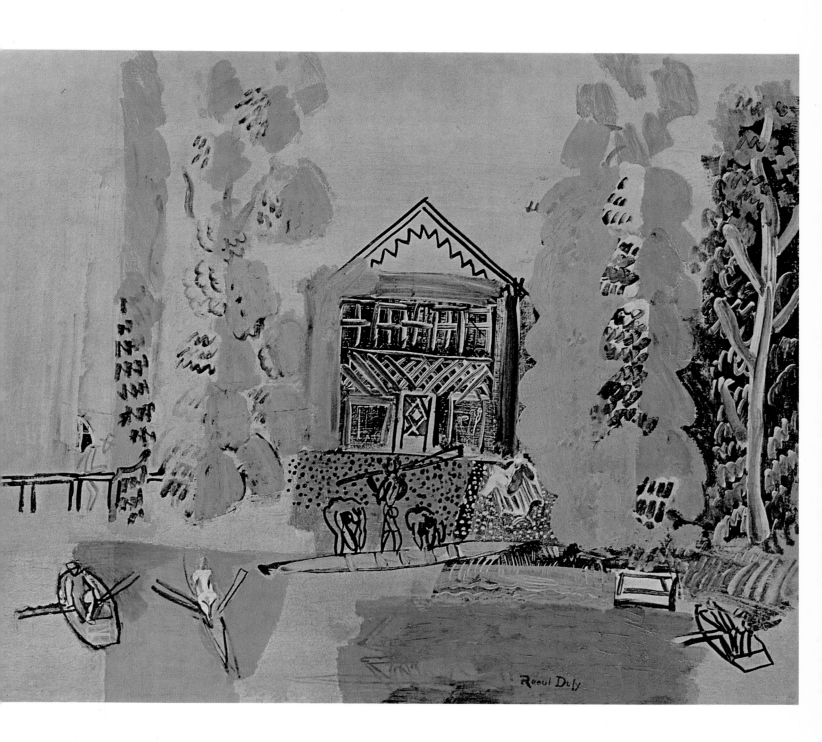

Painted in 1926

SHIPS AT LE HAVRE

Oil on canvas, 38¼ × 45¾"

Perls Galleries, New York

Comparison of this quasi-abstract picture with the still rather realistic *Port of Le Havre*, painted two decades earlier, is most revealing. For the Fauve oil of 1906 was still close to the aesthetics of John Ruskin, who held that a painting should be an exact, detailed, realistic rendering of some object, scene, or event, while the post-Fauve Dufy had swung in the direction of Ruskin's antagonist Whistler, who had declared: "As music is the poetry of sound, so is painting the poetry of sight, and the subject matter has nothing to do with harmony of sound or color."

In *Ships at Le Havre* Dufy, on the strength of memories transformed by the power of imagination, offers a symphony in sensuous, exciting blue. Here the artist has set off this remarkable color with bits of white (largely for the sails, and to outline other forms), with brown (for masts and smoke) and with greens and yellows (for the gigantic butterflies). Dufy was convinced that with the development of photography, painting would become superfluous if it continued to aim only for graphic reproduction. The camera could accomplish this mechanically and more perfectly. "Modern art has a natural tendency towards poetry," he said. "I prefer paintings that lead me into a world of lines and colors to those that pretend to trace what we ourselves can immediately seize with our senses."

80

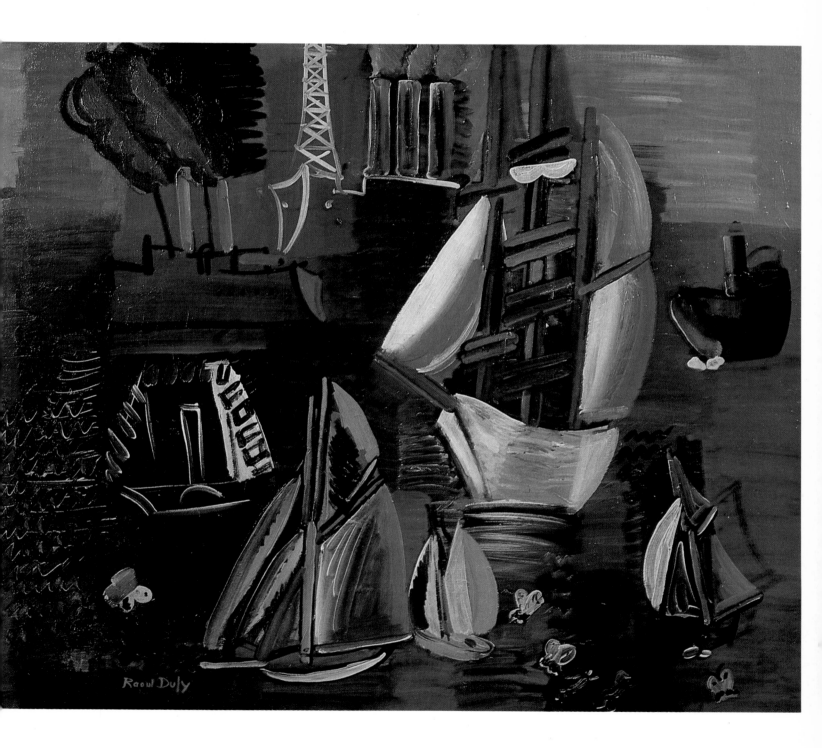

Painted in 1926

LE VERT GALANT

Oil on canvas, 21 1/8 × 25 1/2″

Perls Galleries, New York

The title of this painting, *Le Vert Galant*, might be freely translated as "the Gay Blade." It is the nickname given by France to one of her most outstanding monarchs, Henri IV, the first Bourbon king, who ruled from 1589 to 1610. He was a great warrior, but also an indefatigable builder, to whom Paris owes the Pont-Neuf, among other constructions. Here one sees the bronze equestrian statue of the king, erected on the tapering western end of the Ile de la Cité on what is now called Square du Vert-Galant. The statue faces the Pont-Neuf, the westernmost of the bridges leading across the Ile de la Cité from the Right Bank to the Left Bank.

On the socle is a bronze plaque with a relief celebrating one of the king's exploits (the artist's calligraphic instincts are so pronounced in the plaque that what we see resembles Chinese characters). The statue—a replica of a work by Giovanni da Bologna—is sketched with considerable elegance and skill. In the foreground, note the decorative patterns produced by harlequin railings, the speckled gate, and the wiggly trees. The dome of the Pantheon is seen in the left part of the picture.

82

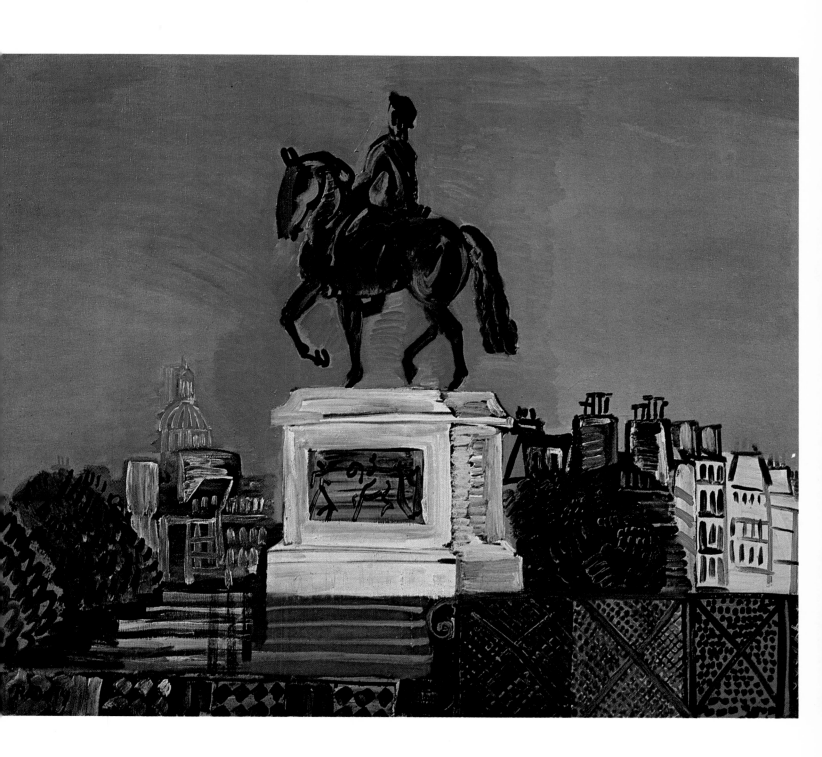

Painted in 1926

LANDSCAPE OF L'ESTEREL

Oil on canvas, 18⅛ × 21⅝"

Perls Galleries, New York

L'Estérel is a region in southern France between Saint-Raphaël and Cannes. Its terrain is composed of porphyry and sandstone rocks largely interspersed with pines and cork-oak trees. It is an area much frequented by vacationers and tourists.

Note how the artist makes subtle use of three dominant colors—blue, green, and red. Even the cart, the horses, and the workman's trousers are painted blue. These dominant notes are set off by black for the trunk of the tree and the nearest part of the foreground, and by accents of white dots and curved lines. Those familiar with the neighborhood will affirm that the red soil and green umbrella pines actually do offer a considerable contrast, which the artist, of course, may have exaggerated in this picture for his own aesthetic reasons. The hanging branches of the foreground tree resemble the claws of some wild tropical animal.

Landscape painting has a relatively short history; not before the sixteenth century did artists take it up for itself. It came into its own in the nineteenth century, but its last enthusiastic practitioners were the Impressionists. Though Gauguin had begun as an Impressionist, he pointed to the end of landscape painting as a topographical venture—the representation of a real place—by stating that the subject was only a point of departure for "symphonies, harmonies that represent nothing real in the vulgar sense of the word." The Fauves went further to shake the tradition that subordinated the painter's vision to the appearance of nature. As this picture indicates, Dufy did not limit color to a merely descriptive function. Though painted in 1926, this is still, with its distortions, especially of color, a "Fauve" landscape. "Truth to nature" gives way to "truth of expression." The artist turned from the objective recording of appearances to a completely subjective creation.

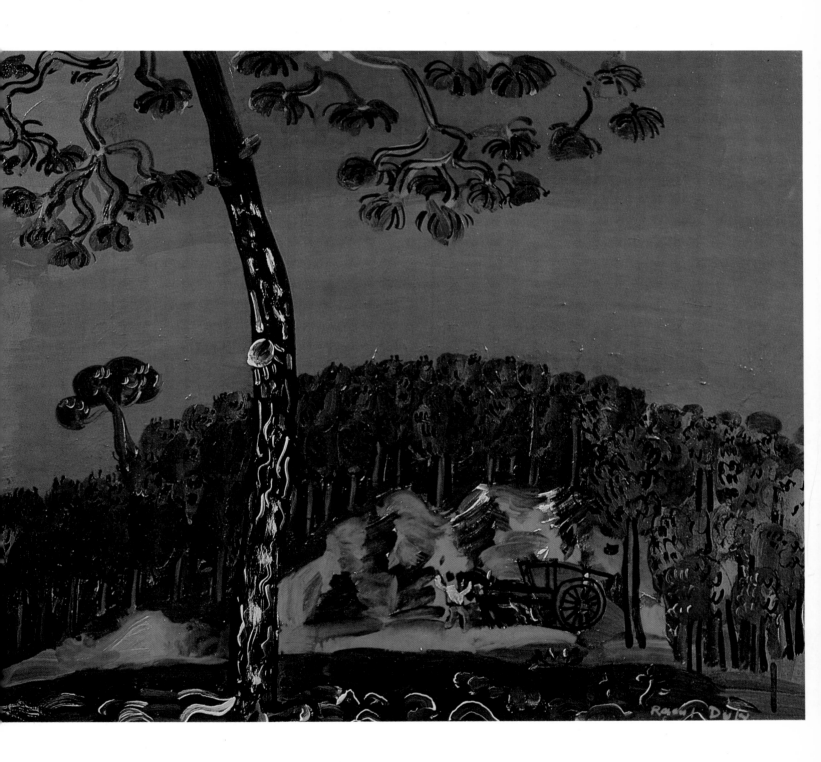

Painted in 1928

NUDE

Oil on canvas, 24½ × 20½″

Collection Mr. and Mrs. Sam Jaffe, Hollywood

Every artist has his own ideal of beauty and his own notion of how the female nude should be presented to represent that ideal. Among Dufy's contemporaries, Modigliani endowed woman with an elongated body upon which he lavished rich oranges and pinks; he liked to show her without any distracting accessories and spurned the convention of using a bit of drapery or the casual gesture of a hand to conceal the genital area. Pascin's often plump nudes are always sexually provocative, their attraction heightened by stockings and jewelry. Dufy's nudes are neither so serene as Modigliani's, nor are they depraved *filles de joie* like Pascin's.

Like a classic representation, Dufy's nude has no hair on her body, but unlike most pre-nineteenth-century nudes, she is too plump and coarse to be called truly attractive. Her flesh is no longer firm, yet this sloe-eyed female is still erotic. Voluptuous in every curve, she probably reminded the artist of the many concubines shown him by the Pasha of Marrakesh during his 1926 trip to Morocco.

The setting here is Dufy's studio in the Impasse de Guelma, a dead-end street in Montmartre where Braque, Suzanne Valadon, and occasionally her son Utrillo were among his neighbors. Notice the two portfolios propped against the brown screen (behind which the model dresses), the pictures hanging on or leaning against the wall (which was actually painted in this particular blue), and the richly patterned, probably Oriental, rugs.

As a composition, the picture is interesting inasmuch as the very simple, uncluttered nude is made to blend into the plain, unadorned screen behind her, but is set off by the flat blue wall and the rich tapestry-like effect of the ornately designed rugs and right half of the picture. Contrasts are also created between the sinewy, undulating, voluptuous line of the figure, followed through in the upper border of the screen, and the geometric forms of the floor, walls, portfolios, and pictures.

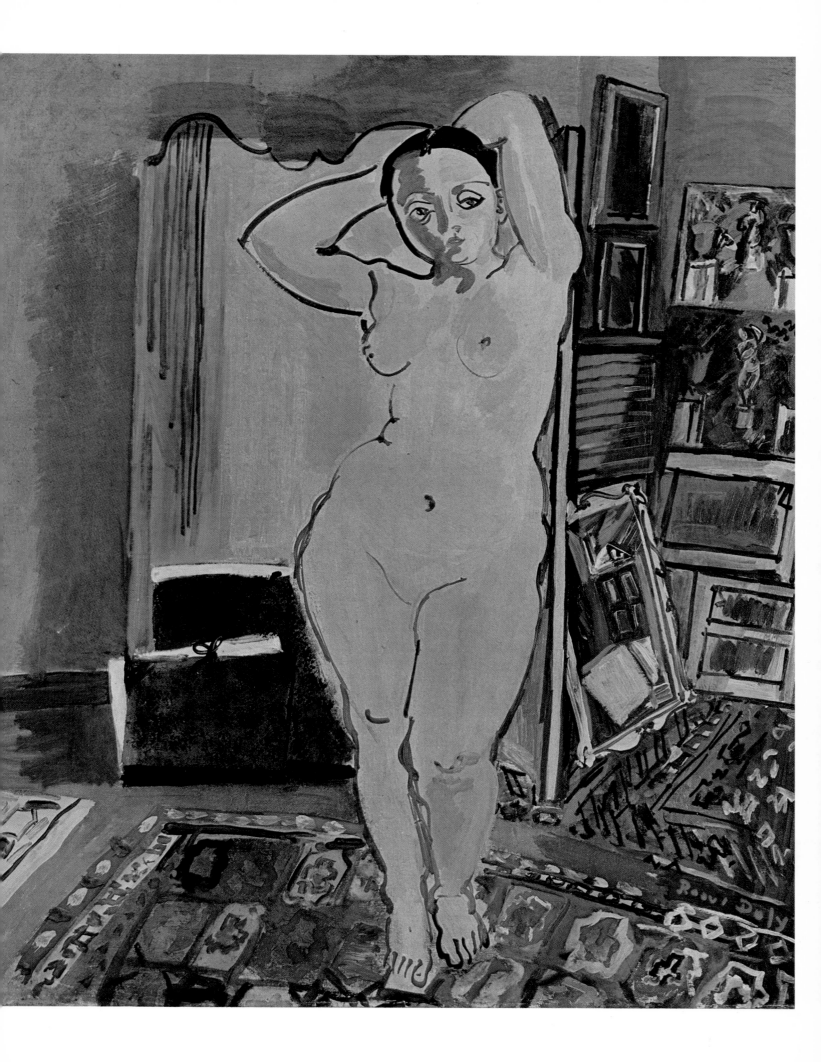

Painted in 1928

INDIAN MODEL IN THE STUDIO
IN L'IMPASSE GUELMA

Oil on canvas, 31 ⅞ × 39⅜"

Collection A. D. Mouradian, Paris

Dufy kept the same studio from 1911 to his death in 1953. Pierre Courthion
has described the Impasse Guelma as "a little haven at the very heart of
Montmartre, hard by but withdrawn from the noise of the Place Pigalle."
It was in this studio that Anmavati Pontry, the sitter in this painting, posed
frequently for Dufy. Although the model is highly individualized—more
so than figures generally are in Dufy's work—the artist's main interest is
not character but design. The sitter seems merely a pretext for rendering
her colorful, richly patterned sari, whose flavor harmonizes with the boldly
designed Oriental rugs, all four of which are different. The pictures visible
on the right side of the painting contribute to the opulent Eastern atmos-
phere. The busy-ness of these objects is both heightened, yet saved from
visual chaos, by the serene expanses of blue wall, brown floor, and the
canvases leaning against door or wall.

All of the four pictures are by Dufy; their subject matter can be
recognized—a homage to Mozart; a picture in which both the Eiffel Tower
and the Arc de Triomphe can be discerned; the rendering of a bather; and
a glimpse of a public square.

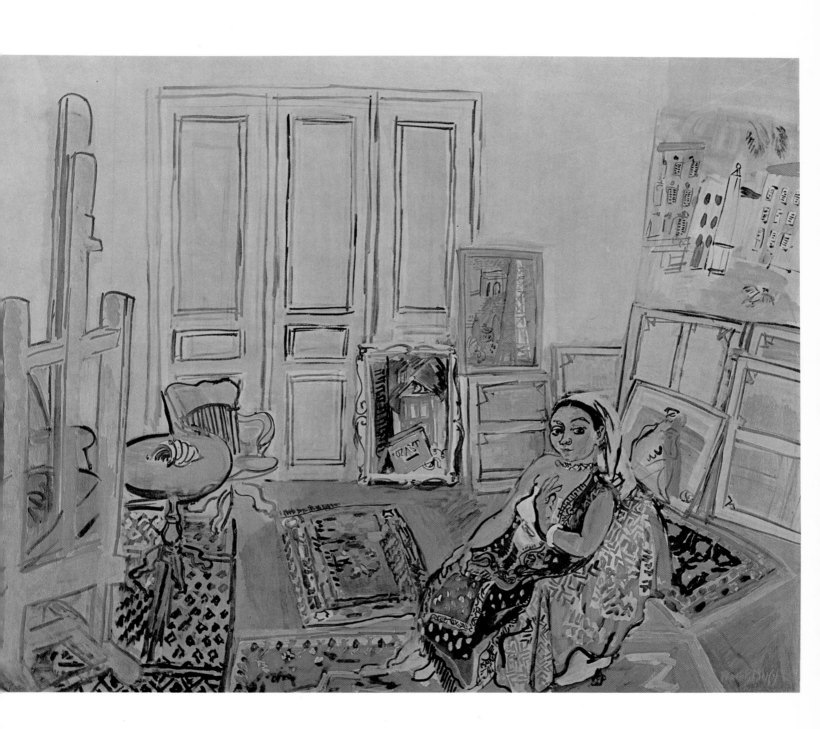

Painted about 1928

STILL LIFE

Watercolor, 21 × 27″

The Evergreen House Foundation, Baltimore

This particular picture is almost an invitation to an *al fresco* luncheon. Everything is ready—the fruit, the wine, the bread, the oil and vinegar bottles, and although the guests are missing, the feeling is that they will arrive momentarily.

If the term "Dufyesque" can be applied justly to any one picture, this still life might well be chosen. For this painting offers a perfect example of Dufy's cursive virtuosity that suggests rather than describes, and that looks so light, swift, graceful, and seemingly effortless that one forgets the years of practice and study that lay behind it. Note the amusing short-hand treatment of leaves in the upper right corner and the witty juxtaposition of gigantic wine bottle and miniature chair. Dufy's remarkable brush-work—combining broad areas of color with sharp, black line—endows everything with vitality, bringing life to inanimate objects.

There is a world of difference between this *Still Life* and the *Still Life with Fruit*, painted some sixteen years earlier, which is darkish, almost gloomy, and not easily recognizable as a work by Dufy. This *nature morte* of 1928 is anything but "dead," but rather a hymn to life, filled as it is with pleasurable suggestions.

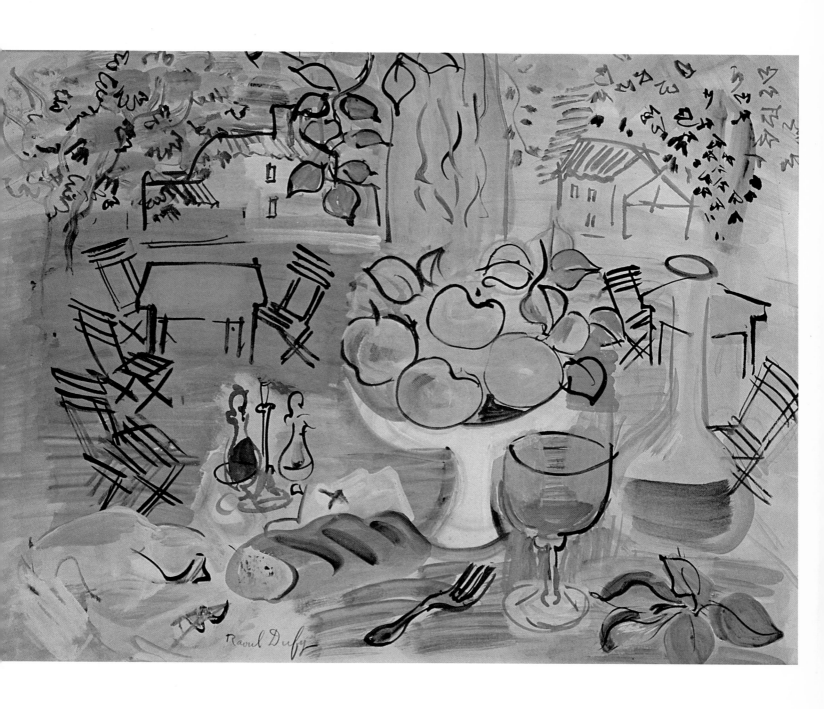

Painted in 1929

THE CASINO AT NICE

Oil on canvas, 19¾ × 24"

Collection Mr. and Mrs. Peter A. Rübel, New York

The Casino de la Jetée was repeatedly painted by Dufy. An unfinished version was found on the easel in his Forcalquier studio at the time of his death (this gambling place, which he still so fondly remembered in the spring of 1953, had been destroyed in World War II and never rebuilt; a modern structure has replaced it several hundred yards inland). The artist was attracted by the building's bizarre features—here it looks like an odd blending of an Oriental mosque, the Taj Mahal, and a Coney Island fun house. The boulevard on which the strollers and the sports cars (typical roadsters of the twenties) can be seen is the famous Promenade des Anglais, with its fine hotels and parks with palm trees.

The Casino was a gathering place for people who came to risk their fortunes on a chance as unreal as the image on this canvas. The yellow, orange, blue, and green tones, combined with melodiously flowing lines, capture perfectly the glittering, highly artificial, and transitory Arabian Nights atmosphere pervading much of the French Riviera.

Note the pleasant contrast between the solid, imposing casino, and the gusty, evanescent weather. The artist clearly states the atmospheric instability in the wildly fluttering tricolors, the choppy surface of the Mediterranean, and most of all in the restless, charged sky with its jagged streaks and billowing clouds. It is the dynamic between repose and motion that brings this painting to life.

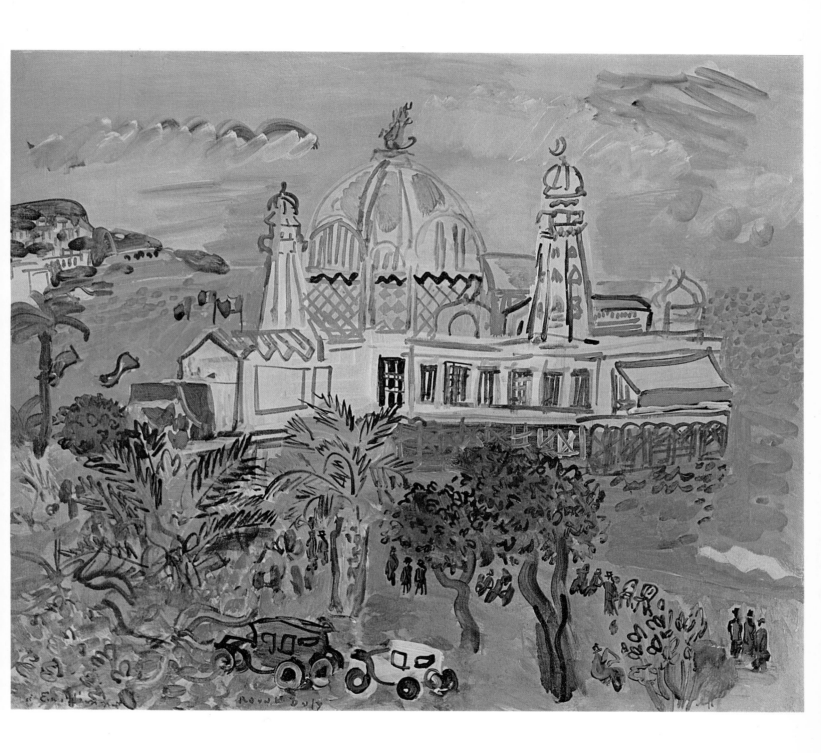

Painted in 1930

INTERIOR WITH A HINDU GIRL

Oil on canvas, 31¾ × 39¼"

Royal Museum of Fine Arts, Copenhagen

Here the model, Anmavati Pontry, does not have to compete visually with
the furnishings of the artist's studio—she is the center of attention. Sitting
comfortably on an upholstered chair, she wears her costly traditional sari
with embroidered borders; her hand is resting against that part of her gar-
ment that drapes across the shoulder. The chair is placed on a small plat-
form like a throne. This pose, as well as the splendid sari and the tapestry
suspended as a backdrop behind her, gives the model a queenly air. With
the exception of the abbreviated sketch that stands for the rug behind the
round table, the floor coverings are hardly described. Note the delightful
floral still life on the table at the left, and, above it, the delicious green and
blue landscape (a Dufy of the late 1920s). The picture on the easel at the
right, set in an elaborate eighteenth-century frame, would not seem to be
one of the master's works.

Dufy's repeated use of this model is not surprising. Like many other
French artists—Delacroix, Chassériau, Gauguin, and Matisse come to
mind—he was fascinated by everything exotic. On a trip to Morocco he
had seen the Sultan's harem, and although he had never been to India, he
could evoke the mysterious charm of that sub-continent by painting this
plump, Hindu beauty.

94

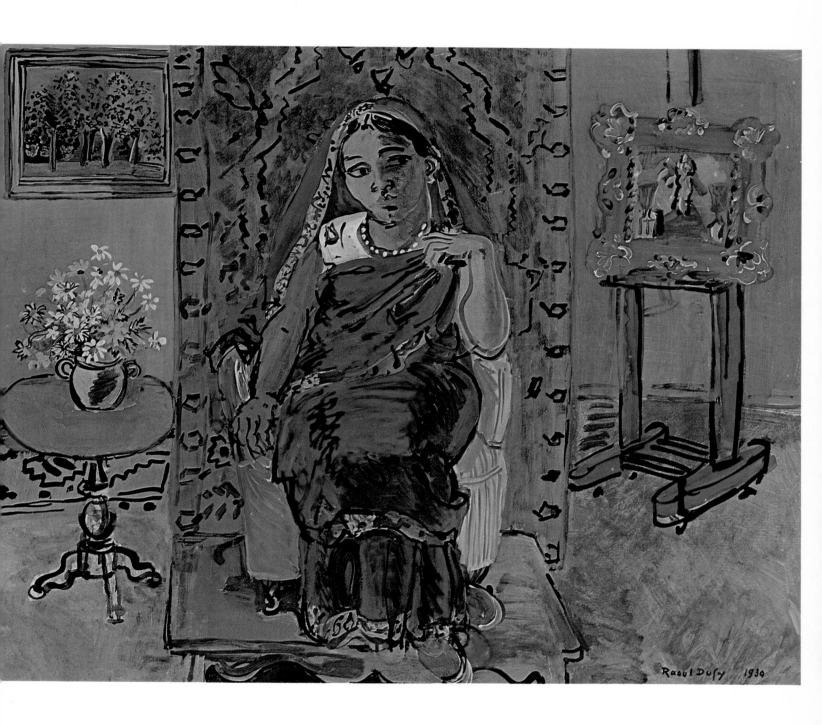

Painted in 1930

RACES AT GOODWOOD

Watercolor and gouache, 19½ × 26″

Collection Mr. and Mrs. Abraham L. Bienstock, New York

Although horse-racing developed in eighteenth-century England, some of the most famous paintings on this theme were done by Frenchmen—in particular Géricault, Manet, and of course, Degas. Dufy discovered the theme for himself about 1923, when his employer, the silk manufacturer Bianchini, advised him to attend the races in order to see what women were wearing. But the painter, whose designs have embellished many a woman's dress, found himself more interested in the race itself.

Subsequently he followed the sport at Deauville and Longchamps in his native country, and at Ascot and Goodwood in England (at Goodwood, in Sussex, races have been held every July since 1802). In this essentially blue-green monochrome, executed lightly and fluidly, the spectators are almost incidental, being frequently rendered as little more than spots of black or brown. Even the horses and riders are only sketchily delineated. Note how Dufy allows the brush to run over the outlines of his forms, unconfined by the demands of color. This brushwork softens the edges of his forms (particularly of the jockeys and horses), blurring and blending them into the surrounding areas and producing a feeling of high speed.

While Dufy's calligraphic brush miraculously conjures up speed on one side, it confines the spectators on the right to absolutely static postures. All the tension comes from the racing horses; the crowds do not appear to be caught up in the excitement. Did Dufy here sense or observe the "traditional" reserve of the British?

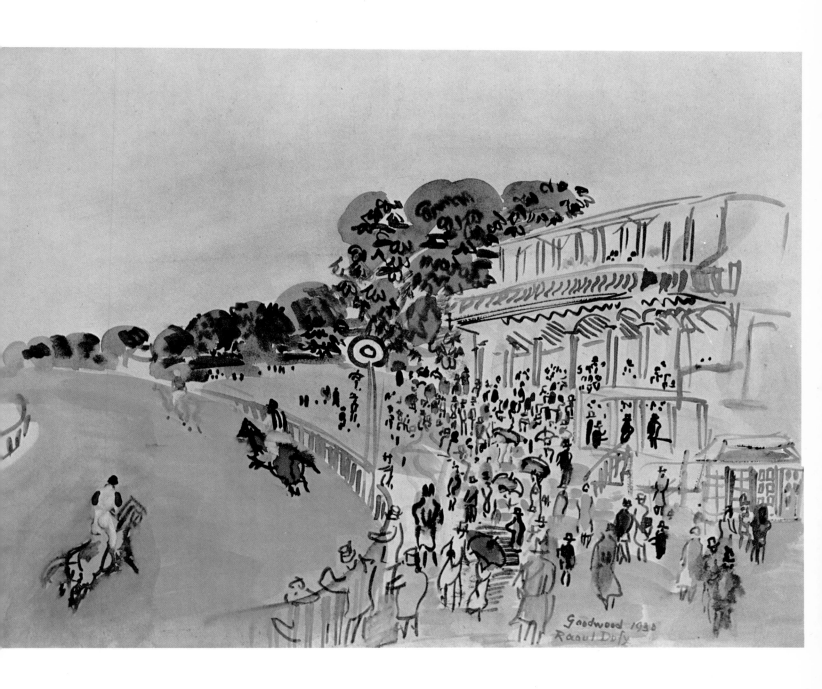

Painted in 1930

THE GATE

Oil on canvas, 51¼ × 63¾"

Collection Evelyn Sharp, New York

Dufy loved to paint the splendid mansions and castles built for aristocrats in the loveliest parts of France. In this Normandy château—owned by a Baron de Rothschild, whose insignia, R, is wrought in the grille—Dufy was attracted by the graceful undulations of the complex trellis-work framed by verticals and horizontals, which was most appealing to his baroque playfulness. Whatever want and misery may exist in the world would seem to stop before this elegant gate. It will not open to anyone who might disturb the aura of charm and tranquillity that emanates from within.

An atmosphere of perfect calm is achieved by the harmony of the predominant colors—the bright yellow-greens and cool blue-greens of the spring foliage, the soft and lavender-blue sky, and the deep purple-blue of the English Channel beyond the reddish gatehouse on the right. This rainbow of pastel colors meets and unites in the gate, which seems to catch and reflect its soothing hues. The patches of hot color contributed by the two houses create a dynamic vibration in this predominantly cool setting.

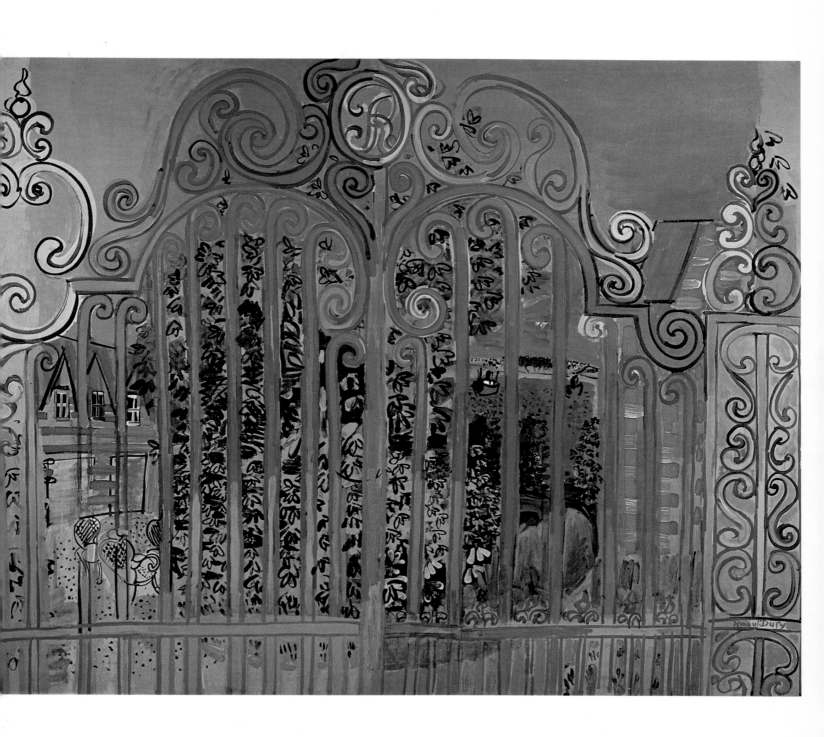

Painted in 1930

PORTRAIT OF MME DUFY

Oil on canvas, 39⅜ × 31⅞"

Musée Massena, Nice

Little is known about the artist's wife, Eugénie (called Emilienne), *née* Brisson, a native of Nice, who prior to her marriage was employed as a milliner in a shop in Le Havre. Nor do we know much about the nature of the couple's relations (although it is certain that during World War II the Dufys separated for good). At least one other portrait of her was painted by Dufy in 1915. In the earlier portrait the position of the hands is the same as in this picture, for which she posed fifteen years later.

Dufy produced few portraits, yet he was very competent in this field. He seemed to sense exactly how far he could deviate from the forms of nature in the process of abstraction without losing either psychological or physiological accuracy.

In its simplicity there is a similarity between this portrait and the early *Woman in Pink*. Here the canvas is even more austere. Except for the gaily colored tablecloth upon which the artist's wife leans, the back of an old-fashioned chair, and the flat blue background (probably identical with the cerulean blue of his studio), there is nothing to distract our eye from the sitter. Though he is no Kokoschka giving us X-ray insights into his sitter's psychic depths, Dufy nevertheless delineates the character of his wife. Before us we have a chic, patient, self-contained, yet tense woman, whose matronly figure is perhaps echoed in the central section of the chair's back. The hands, delicately touching the cheeks, are perhaps the most striking element in the picture. The contrast in Mme Dufy's character is established by the contradiction between the calm face and the restless hands. This juxtaposition states very clearly the conflict. Here, as in the *Woman in Pink*, the artist consciously employs the hands to reveal the sitter's personality and character. Moreover, here he is using the busy pattern of dress and tablecloth to emphasize the nervousness of the hands, just as he seems to use the serene blue background to "back up" the expression of the face.

The Dufys had no children. Mme Dufy died in Nice in 1962, nine years after her estranged husband.

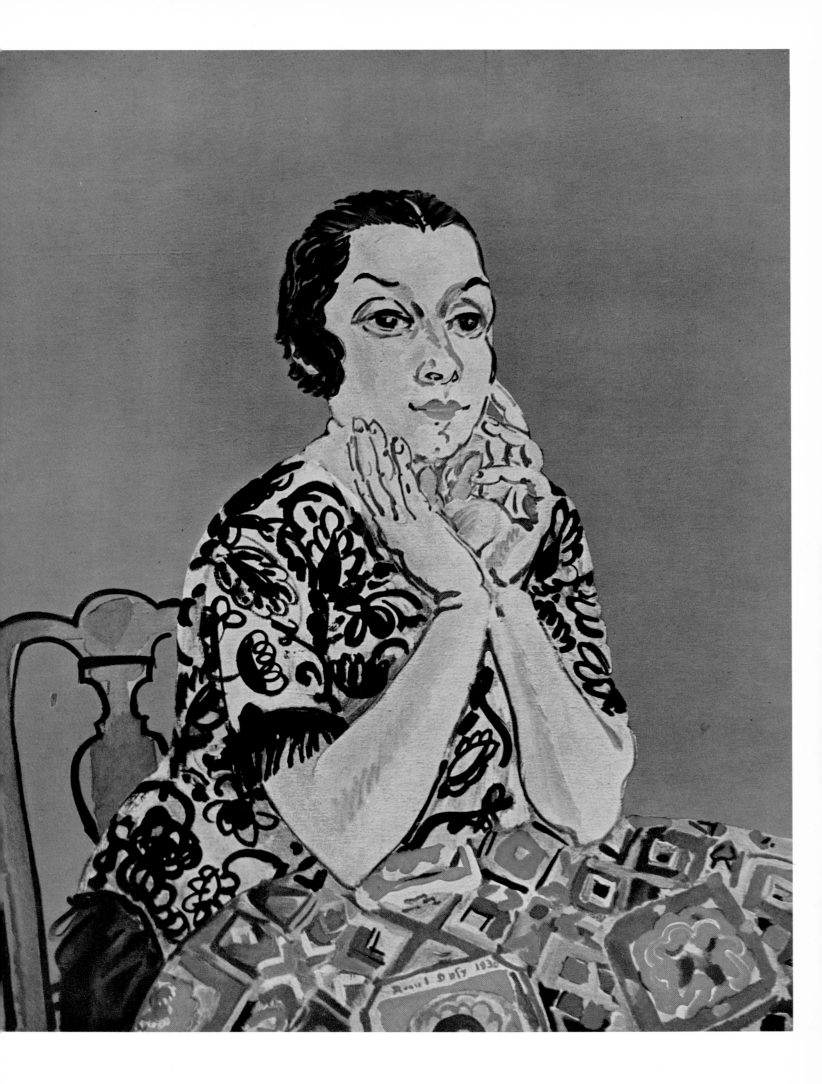

Painted in 1933

HOUSES AT TROUVILLE

Oil on canvas, 19⅝ × 28¾″

Musée d'Art Moderne de la Ville de Paris

A scene which many would see as fixed and static, Dufy perceived as a shifting, ever changing image. He observed it with the same curiosity and excitement that prompted the "floating world" artists of Japan to mirror in countless gaily colored prints the transient nature of everyday life. The center of Trouville is not particularly attractive to the average tourist, who quickly traverses it on his way to the beach. Dufy, however, looked with delight and perhaps amusement at the row of ordinary houses and the crowd on the square, transmitting his pleasure through wittily applied color spots such as the yellow dress and cross-hatched lines dashed in here and there. Such details are set down with greater deliberation than this apparently spontaneous sketch would have us assume. Amid this utterly nondescript architecture, the Victorian mansion with turreted tower, and further to the right, the edge of an Italian-style villa seem strangely out of place.

It might be noted that the buildings are painted in intense colors in the center of the composition. Then they gradually diminish in intensity as they approach the left and right edges, until, at the edges themselves, they are practically colorless. This, by the way, is a markedly horizontal composition. Dufy is bending the laws of color perspective to suit his needs. By lightening his tones not from foreground to background, but from the center to the edges, he is establishing a feeling of space with width rather than depth. The horizontal stripes and calligrapic strokes on the buildings are not placed for design and textural reasons only. Equally important, they graphically emphasize the horizontal exploration of space that has been coloristically established.

The picture is to be found, not in the Musée National d'Art Moderne, but next door in the Musée d'Art Moderne de la Ville de Paris, opened as recently as 1961, and chiefly containing twentieth-century art transferred from the Petit Palais.

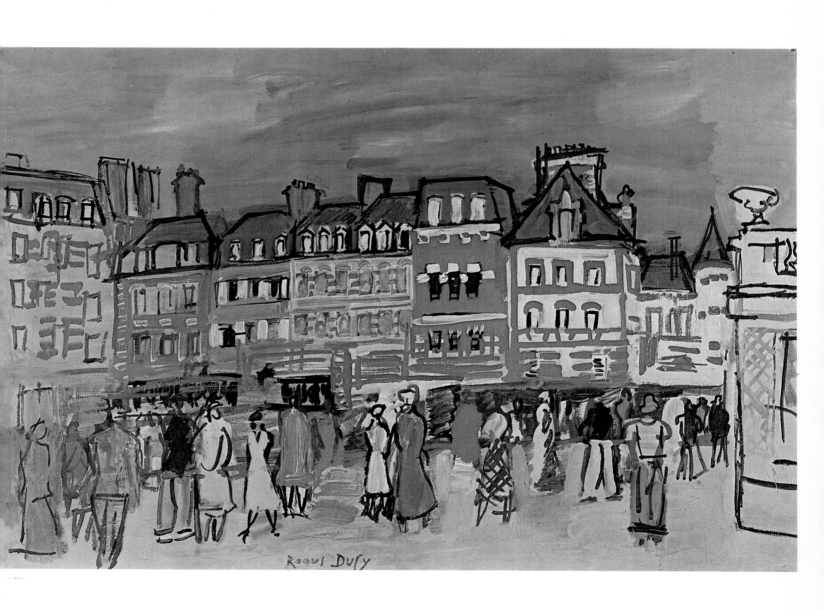

Painted in 1935

HARBOR AT DEAUVILLE

Oil on canvas, 25⅝ × 31⅞"

Collection Robert Nordmann, Geneva

Fifty-six years before Dufy set up his easel, Claude Monet painted the same entrance to this harbor, seen from Trouville, on the other side of the Touques River. Monet painstakingly depicted sky and sea, embankments, ships, fishermen, and above all, the reflections of sails and hulls on the shimmering water.

Dufy, after his Impressionist beginnings, never again practiced this art of verisimilitude. In *Harbor at Deauville*, for example, he merely abstracts from the scene a few essential characteristic forms, arranging them into a strikingly beautiful design that suggests much more than it actually defines. Note the interplay of verticals, horizontals, and diagonals in the forest of masts, and the quick broad strokes that serve to indicate water and sky. Though the artist handles his subject in a highly informal way, the bustle of organized activity on the part of the sportsmen can nevertheless be clearly felt. This atmosphere of purposeful activity and movement is communicated entirely by the artist's brushwork. There is nothing tentative or timid here. Dufy, from all appearances, has literally attacked his canvas with a barrage of bold, vigorous strokes that instill vitality wherever they fall.

In his Fauve period, Dufy would have painted the scene in large splashes of heavily applied color. By 1935, at the height of his fame and the peak of his career, he applied his oil colors lightly and loosely, in thin strokes that give his pictures the charming sketchiness of a watercolor.

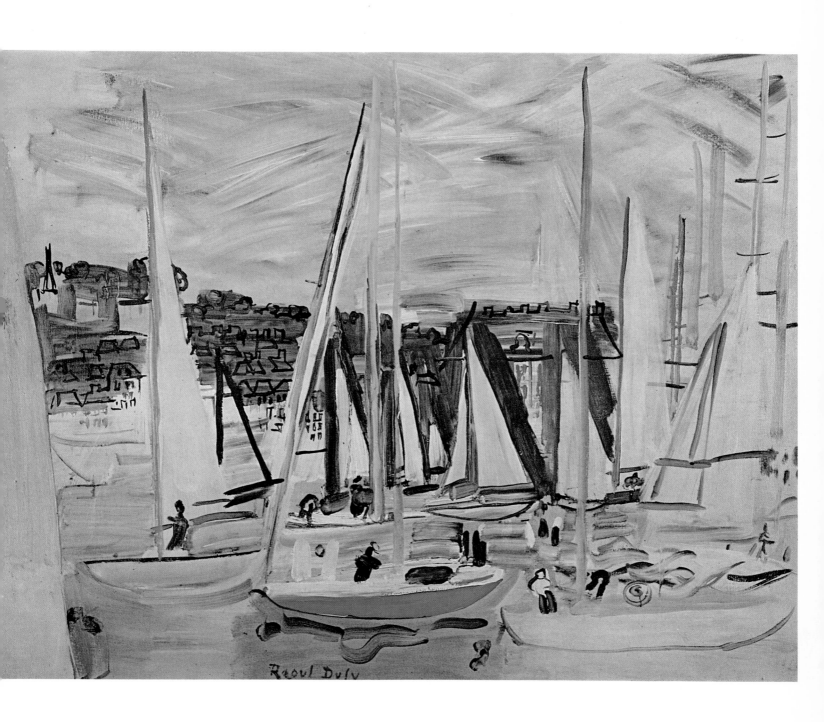

Painted in 1935–50

RACETRACK AT DEAUVILLE

Oil on canvas, 29½ × 32″

Collection Henri Gaffié, Beaulieu-sur-Mer

No race is on. The horses are being exercised in the paddock and on the track which may tomorrow be the scene of great excitement. Through his exquisite palette alone, the artist has transformed an otherwise undramatic turf scene into a fairyland vision. Like a watercolorist working over a toned ground, Dufy has brushed in "washes" of oil that cover the entire surface with vibrant hues ranging from lavender to blue to green to yellow. Though the central portion of the picture is rendered in "natural" colors (green grass, blue sky), the left and right margins depart from nature entirely.

Over this rainbow and sun-drenched backdrop, Dufy has dashed in his scene in the sketchiest way. Most of the forms are hardly more than outlines hastily drawn in black, red, orange, or blue, and filled in by the background colors that are allowed to assert themselves with no surface interference. Only a few foreground figures, the horses and jockeys, and the tiny horse and rider in the middle of the green turf, are rendered opaquely and in contrasting colors to give substance and weight to an essentially airy, transparent composition.

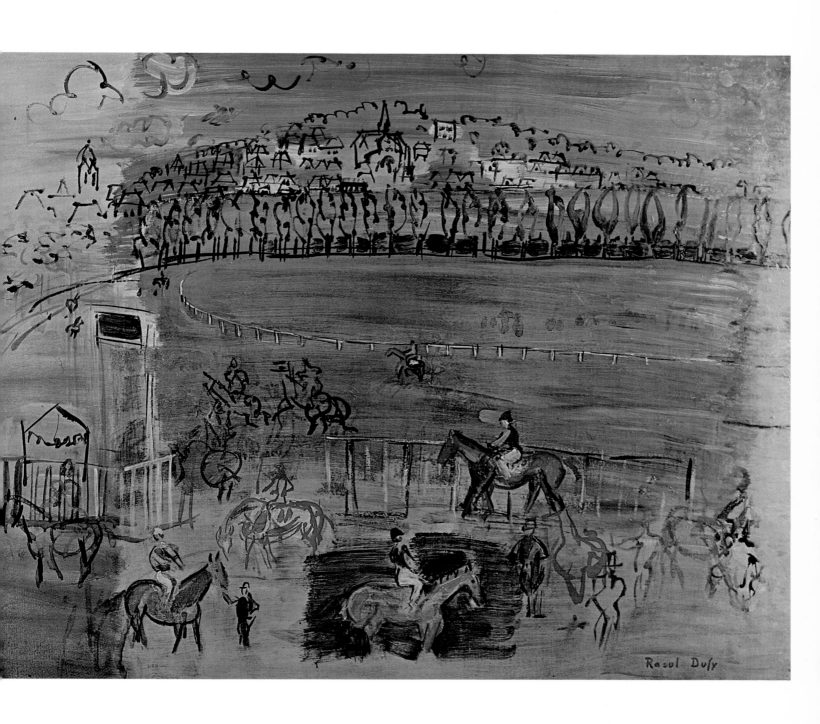

Painted in 1936

AMPHITRITE

Oil on canvas, 73½ × 62½"

Findlay Galleries, New York

In ancient Greek mythology, Amphitrite is a sea goddess, daughter of Nereus and wife of Poseidon. She is usually represented in classic works of art either enthroned beside her husband, or riding with him, attended by tritons and nereids, in a chariot drawn by sea-horses or other fabulous underwater creatures.

Dufy was not particularly interested in any literal version of an old myth. His Amphitrite is a plump young bather, sitting on a very unclassical beach-towel and wearing an equally unclassical string of pearls. Her surroundings are also mythically anachronistic—steamships, modern sailboats, a Mediterranean harbor town, and an assortment of twentieth-century people who are shown fishing, boating, swimming, or just looking on. The picture is a compendium of the sights and phenomena that Dufy liked best. Because of the picture's very personal quality, one is reminded of Chagall, who also included in his later works all the motifs that had inspired him and given him pleasure, as well as some of his tools (here Dufy has placed a tiny palette in the lower left hand corner).

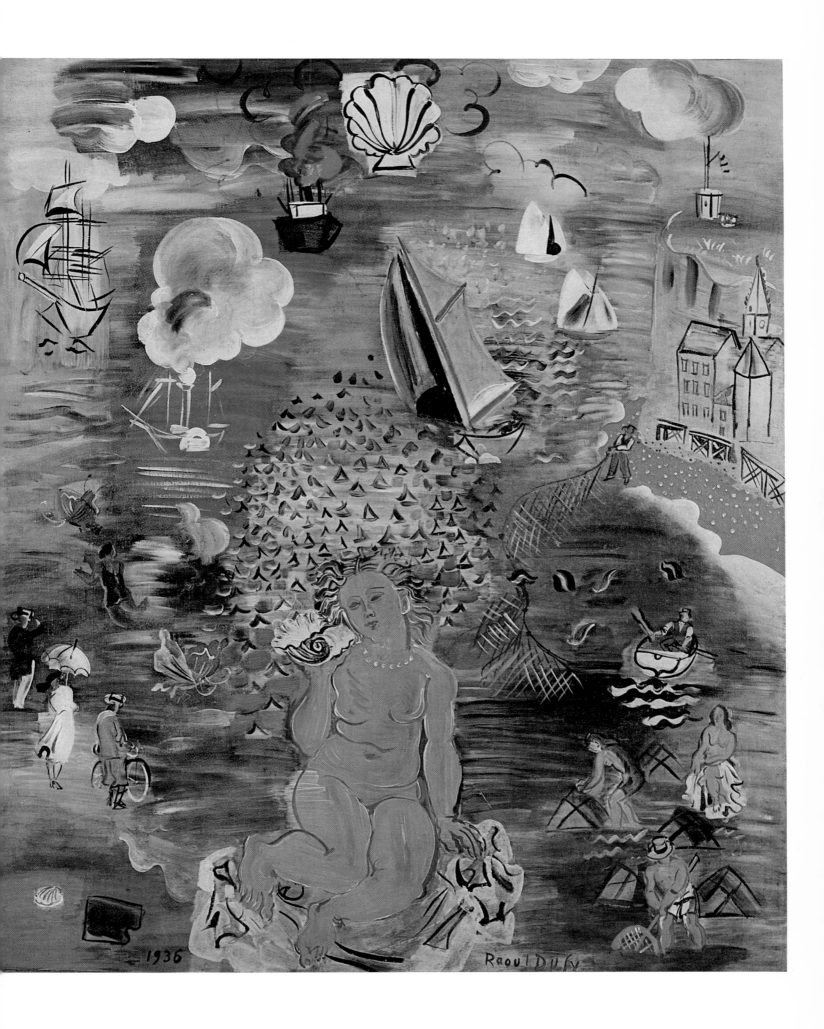

Painted in 1936

THE ROYAL YACHT CLUB
AT COWES

Oil on canvas, 18½ × 25½"

Abrams Family Collection, New York

Cowes is a port and seaside resort off the south coast of England, on the Isle of Wight. It is the headquarters of the Royal Yacht Squadron, founded in 1812. The island's yachting tradition goes back to the days of the first Queen Elizabeth.

Dufy obviously loved the convivial gathering of the well-to-do, whom he observed, perhaps from a distance, with amusement and mild irony. Actually, the artist was more entranced by the play of colors and unusual patterns than by the antics of high society. He has been called the Watteau of his time, a reference to the *fêtes* painted by that eighteenth-century French master. However, Dufy preferred to be compared to a later French artist, for he once remarked, "If Fragonard could be so gay about the life of his time, why can't I be just as gay about mine?"

Indeed, Dufy loved to combine seascapes and interiors, as he has done in this picture, and he was fond, too, of portraying rich people on holiday. Here, three gentlemen leisurely wait for the butler to serve drinks. Their wealth or elite status has rendered them phlegmatic and blasé; they appear stiff and lifeless. In terms of movement, the artist makes almost no distinction between the empty chairs and those that are occupied. In the center, the unadorned circle that stands for a table top functions as a hub, drawing together and holding the forms, arranged like spokes around it. The patterns of the flowered upholstery also play an important role. Note, on the wall at the left, the picture of a prize-winning yacht hanging above the curlicued console. The glass porch commands a view of the yacht basin, opening up the composition so that it flows from a tightly confined area into the wide horizon beyond.

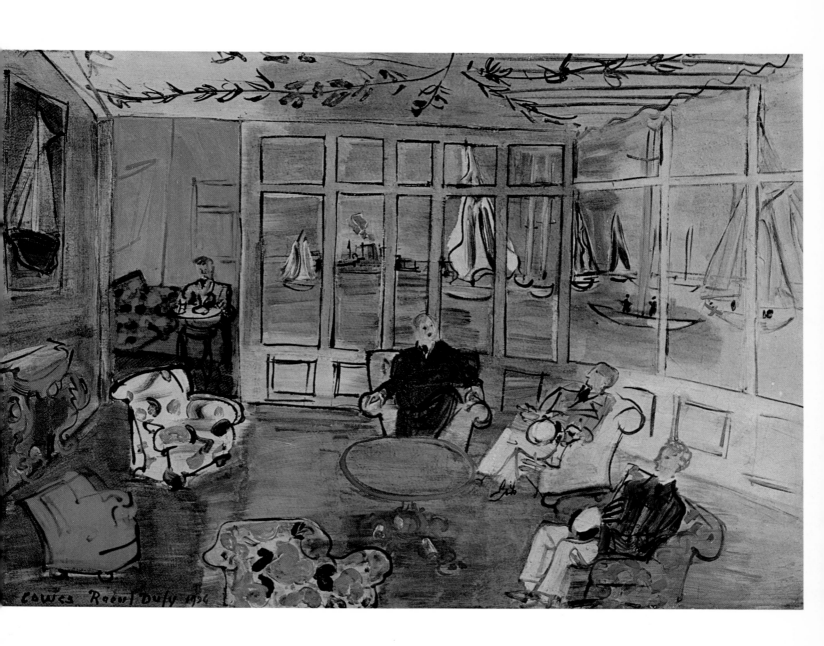

Painted in 1936–37

ELECTRICITY

Watercolor, 19¾ × 26"

Collection Henri Gaffié, Beaulieu-sur-Mer

At the request of the Paris Electrical Supply Company, Dufy executed an enormous mural—measuring almost two hundred by thirty-five feet, and painted in oil on two hundred and fifty panels—dealing with the history of electricity. It was shown in the firm's pavilion at the Paris World's Fair in 1937. He made numerous preparatory sketches for this major work, of which this watercolor is one. On the floor of the powerhouse, dynamos can be seen. The machines are flanked on either side by the ordinary people who benefit from all great inventions. Assembled above them, like gods in the clouds, are the scientists and engineers who made the critical discoveries in the field of electricity.

In conceiving this mural, the artist had to deal with a concept inherently alien to art—that of time. The dimension of time is familiar to composers, choreographers, novelists, and playwrights, but not to those who work in the plastic arts. Dufy, because of the nature of the composition, had to tell a story, had to deal simultaneously with past and present. He solved the problem by separating time into two horizontal compositional planes, the upper representing the past, the lower the present. He unified the composition by using the central spatial band merely as a design element whose essentially vertical thrust connects the two planes.

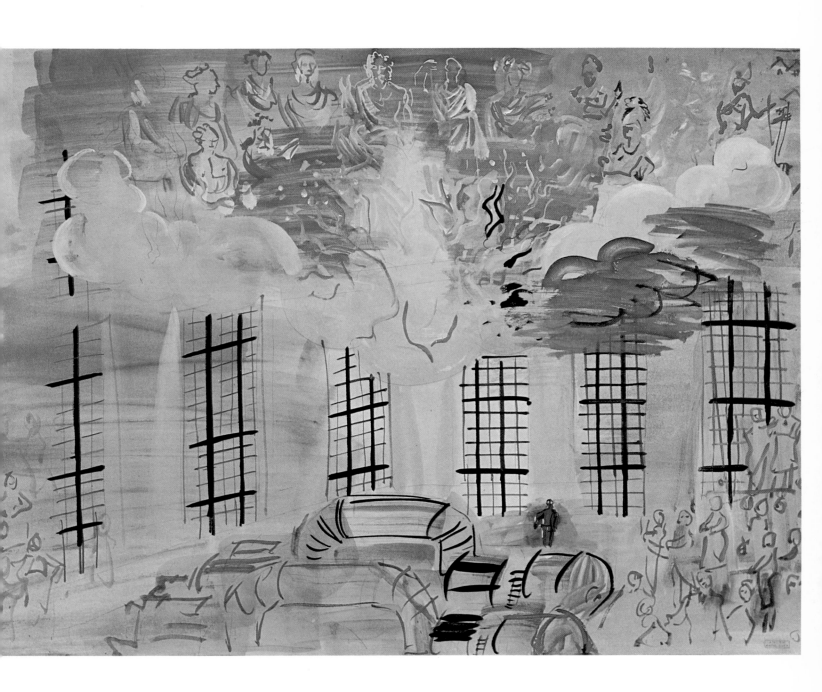

Painted in 1940

BOUQUET OF ROSES

Watercolor and gouache, 12¼ × 16″

Collection Mrs. Albert D. Lasker, New York

Aquarelles have engaged the skills of Chinese, Japanese, Persian, and Indian artists. Their transparent colors have also been exploited by such European masters as Albrecht Dürer and J. M. W. Turner. This is the most elusive and demanding of all media—one that calls for the utmost spontaneity of vision and swiftness of work. One stroke misplaced and the artist may have to abandon the picture, since, unlike oil, watercolor cannot be corrected or worked over.

It took Dufy years of effort to acquire the facility to achieve the miracle presented here. "To my mind," he once mused, "watercolors give the artist maximum latitude for improvisation. The medium is all but immaterial, color transitions coming about automatically thanks to the white of the paper." He was always fond of flowers, familiar with every-thing botanical, and knowledgeable about the complex forms of petals, calices, stems, and leaves. To carry over this knowledge into painting, he sought out the color patch that best rendered their mass: "A peremptory patch of color," as it was described by Colette, whose *Pour un Herbier* Dufy illustrated with dazzling wit.

He conveys less interest, however, in botanical fidelity than in triumphantly wielding his carefully chosen pigments in the subtle nuances that are the glory of watercolor.

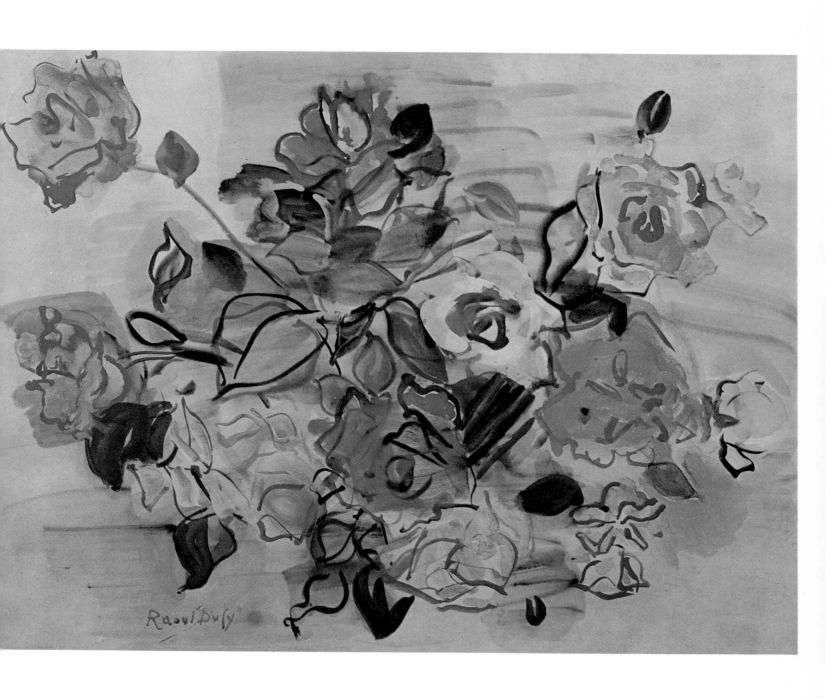

Painted about 1940

THE THOROUGHBRED

Oil on canvas, 18 × 21½"

Collection Monroe Gutman, New York

The French term for a thoroughbred is *pur sang*, literally "pure blood," referring to a race horse of pure breed, whose pedigree has been recorded for a number of generations in the stud-book. Dufy was among the thousands of artists struck by the beauty of the horse. Among them were Chinese potters as well as the anonymous makers of the Parthenon frieze, and of the antique bronze horses overlooking Saint Mark's Square in Venice, and, of course, numerous painters and sculptors from the early Renaissance onward. One may say that, beginning in the early 1920s, the subject of race horses and jockeys runs like a leitmotif through Dufy's work.

While he admired the elegant, rippling movement of the horses, and while he was inspired by the world of horse racing, his paintings on the theme are primarily poems in color rather than accurate descriptions of what a sportsman or spectator sees. The emphasis here is on the subtle interplay of greens, to which two or three other colors are added. Horse and jockey are quite naturalistically drawn and painted. In accordance with tradition, the gentlemen and the lady are very formally dressed.

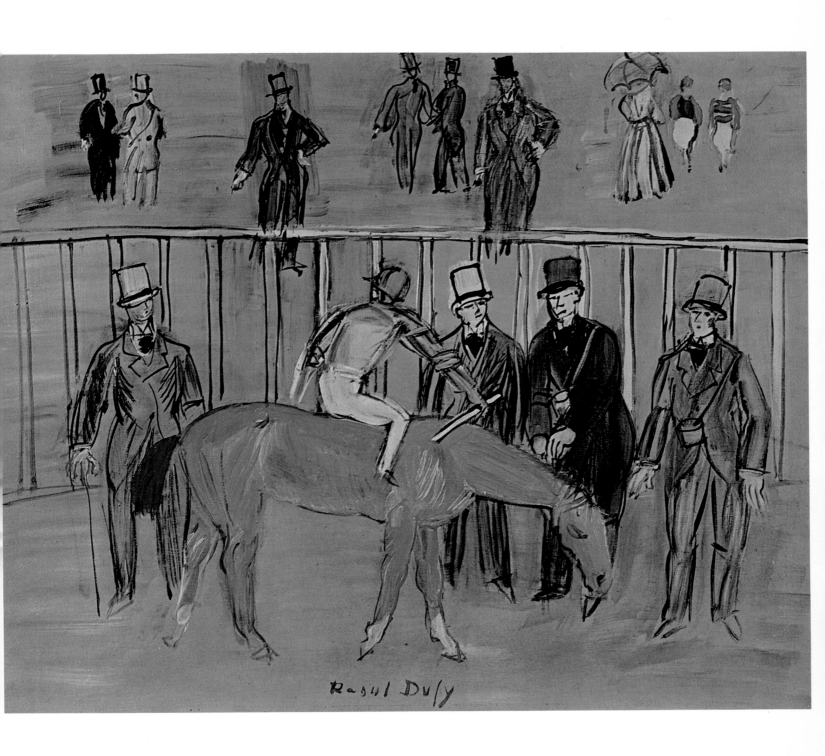

RED CONCERT

Oil on canvas, 13 × 16⅛″

Collection Mr. and Mrs. Peter A. Rübel, New York

An amateur violinist, Dufy shared a love for music with his family; two of his brothers were professional musicians, and one of them, Gaston, who became a music critic, kept Raoul supplied with passes to concerts. Among Raoul Dufy's friends were several celebrated musicians, including the conductor Charles Munch, who recalled:

"It was during the 1930s that I first met Raoul Dufy. At that time he regularly attended the rehearsals of the Paris Conservatory Orchestra, of which I was conductor. Unobtrusively, he would go up to the back row and take his seat beside Passerone, the famous percussion player. I can see him now, at the foot of the organ, crouching over his paper, drawing away. It was there, among us musicians, as we rehearsed our program, that he conceived his series of *Orchestras.*"

Another friend, the cellist Pablo Casals, once remarked that Dufy worked out so subtle an interpretation of music that he, Casals, would know in what key the particular piece was written, even if he could not tell exactly what music the orchestra was playing.

Here the musicians look more like notes on a sheet of music than like real people. But the agitated movements of the players and the weaving patterns of form and sound are superbly translated into vibrating line. *Red Concert* is a sample of what Dufy called "tonal painting," a phenomenon of his last years in which one color dominates each picture. In this case, it is a subtle red, fraught with mystery. Produced by one who had "an eye for music," this oil comes as near to the feeling of music as painting can.

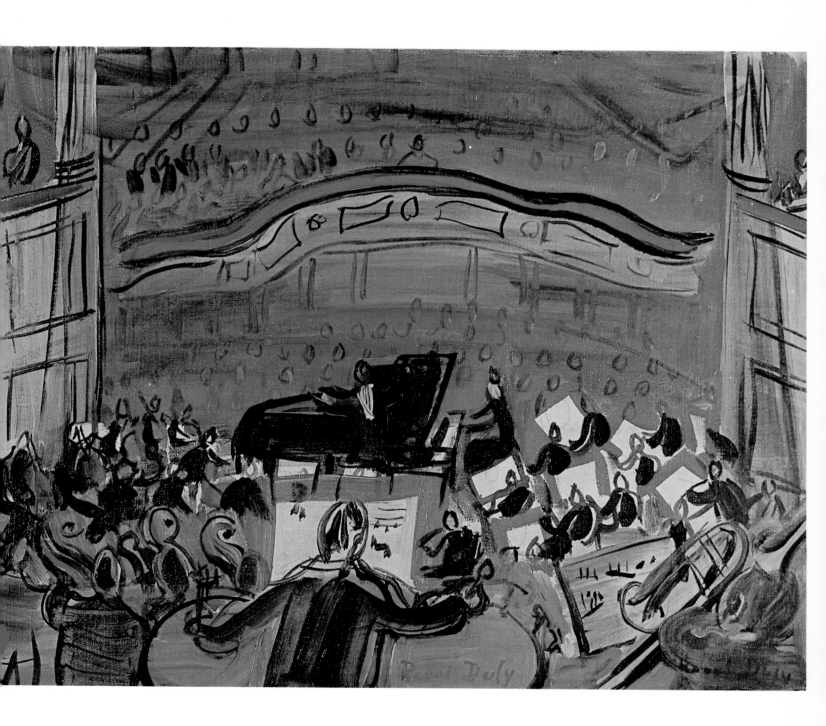

Painted in 1948

BULLFIGHT

Oil on canvas, 13 × 16⅛″

Musée Fabre, Montpellier

Around 1948, Dufy executed many "black paintings." Concerning black, Dufy once remarked to a biographer that "the sun at its zenith is black; one is blinded by it and sees nothing. . . . For me black dominates. One must begin with black and attempt a transposition, a composition that finds its luminosity in color contrasts."

In his choice of subject, the *corrida*, Dufy had a long tradition behind him. Goya was perhaps the first to capture the essence of the bullfight. The Spanish painter and print-maker was fascinated by the violence and fantasy ritualized into a ballet-like trial of strength, cunning, and endurance between man and beast.

Here, there is a curious coordination of primitive features in the foreground and Expressionist qualities in the background. The bull looks as though it had been scratched into the wall of a prehistoric cave. Except for the figure on the left, which is rendered somewhat "realistically," all other figures are hardly more than a single brushstroke covered with a few touches of black line. The whole concept is highly stylized and the scene—which in life is filled with movement and charged with intensity—as Dufy paints it is fixed, frozen, and unemotional. Whatever sense of movement there is appears in the bare trees, just off center to the right.

The tricolor indicates that the scene is the south of France where bullfights are allowed to be held.

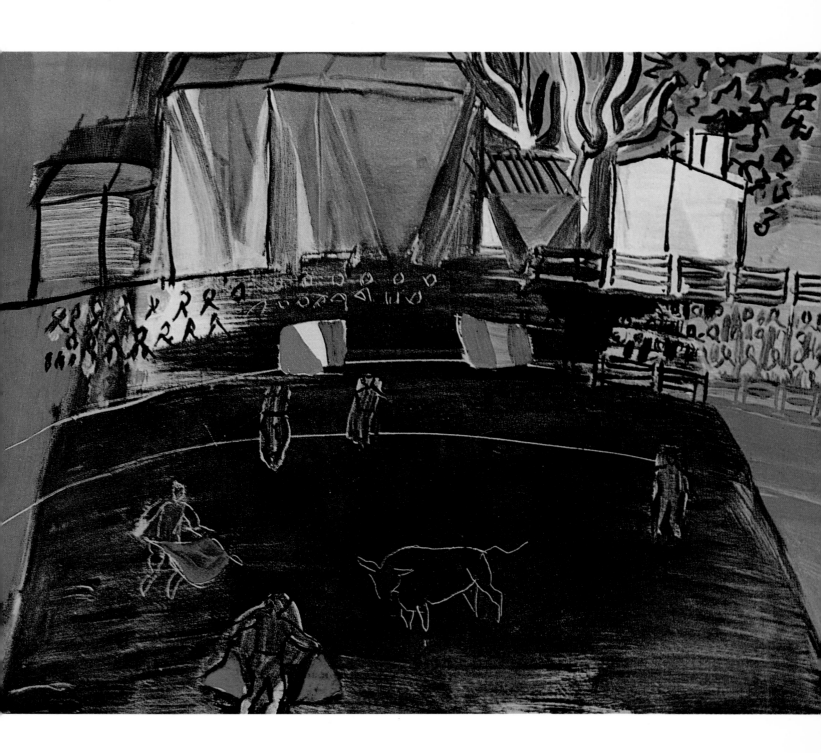

Painted in 1949

YELLOW CONSOLE WITH VIOLIN

Oil on canvas, 39½ × 31¼"

Collection Sam and Ayala Zacks, Toronto

This particular Louis XIV console appears in many of Dufy's drawings and paintings, for it stood in his studio. The painting is typical of Dufy's final period, when he often simplified his palette by confining himself to two or three hues. Though it was painted at a time when he was in constant pain from arthritis, it is as gay and lively as ever.

Executed in washes of golden ocher, this picture suggests an allegretto by Mozart, whose Rococo spirit, aristocratic and refined, was very much akin to that of the painter born more than a century later. But do not try to decipher the score of music—the sheet is there for its fascinating pattern that complements the design of the richly carved console. It also adds an element of realism to the golden fantasy of the picture—so much so that the sheet of music looks as though it had been taken from life and glued over the painting, like a collage.

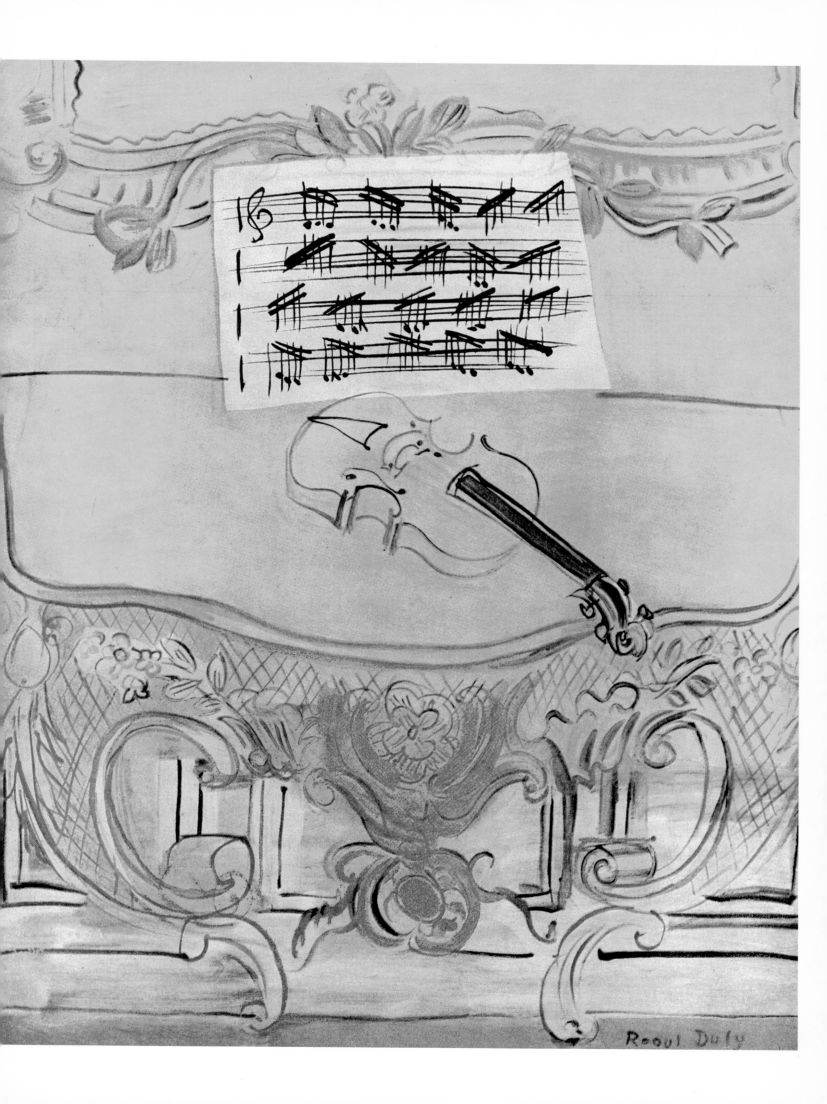

Painted in 1949

THRESHING

Oil on canvas, 18⅛ × 21⅝"

Formerly collection Louis Carré, Paris

Harvest scenes have inspired the painters of medieval Books of Hours as well as such modernists as Monet, Gauguin, Van Gogh, and Vlaminck. Though a native of a large port-city, and for most of his life a resident of Paris, Dufy was very fond of the French countryside, with its wheatfields and its scenes of agricultural labor. Here Dufy exploits the dramatic clash between the greenish yellow haystacks and the blue-plum-colored sky as he depicts farmers hurrying to bring in their grain before the storm breaks. The picture's dynamism is enhanced by the puff of smoke and the rotary movement of the wheel. Although the picture was done in the late forties, it seems more like a subject the artist may have seen in the twenties, since by 1949 more modern machinery was generally in use than what appears in this picture. Dufy continues to rely on his favorite technique of brushing in very broad areas of color and then defining the forms over these areas with strokes of black line. Even the texture of the haystack is established in this way.

One may wonder how Monet would have rendered this scene. A partial answer can be found in Raymond Cogniat's introduction to the catalogue of the Tate Gallery's Dufy memorial exhibition (1954): "Monet's haystacks, his Rouen cathedrals, are conditioned by the weather or the time of the day, depending on the clarity of the atmosphere or the season of the year; that is to say, the artist submits willingly to ideas dictated by circumstances of light or temperature, things outside, whereas Dufy imposes on a picture his individual and personal vision." Moreover, in Impressionist landscapes, the sky is usually a soft, light blue, through which a few small white clouds are floating. Here, the sky is dark and dramatic, as if foreboding a storm.

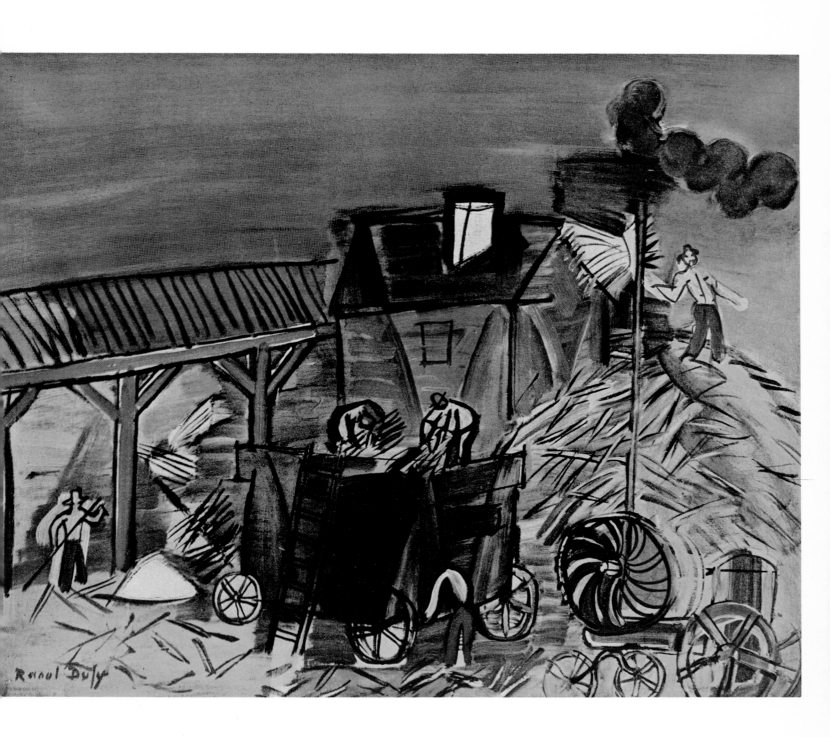

Painted in 1953

ANEMONES

Gouache, 19⅝ × 24″

Collection Henri Gaffié, Beaulieu-sur-Mer

Painted a few days before his death, this fresh and lively picture is Dufy's artistic testament. Dufy was one of the last painters of flowers. Of those deeply fascinated by the subject, only the elderly Marc Chagall and Oskar Kokoschka survive. The apparent informality of the blossoms is deceptive. Indeed, this charmingly casual bouquet is actually carefully arranged into a spiraling composition that widens as it twists its way up from a plaited base. The artist excludes any element that would detract from the glorious color. The background is a transparent wash of the most subtle mauve, and even the clean vase has no highlight to clutter the pictorial space.

Flower painting in Europe developed in the Low Countries; in the seventeenth century, the Flemish Jan Bruegel the Younger and his son, Abraham, were notable practitioners. These Old Masters were interested in meticulous, naturalistic detail; Dufy emphasized the surface charm of flowers, and even more, his reactions to them. Of all flowers, anemones were Dufy's favorites. He loved their brilliant reds and purples that vied with the colors of his palette. Anemones can be found in all Mediterranean countries, and are said to be the "lilies of the field" mentioned in the Gospels. They were used for garlands by the Greeks and Romans. In this picture, Dufy does not bother to give us a botanically accurate rendering of this wind-flower (in Greek, *anemos* means "wind"). Instead, he tries, by a charmingly subtle simplification, "to produce an image, not having the appearance, but retaining the force of reality . . ." As he also wrote in his notebooks: "The marks he [the aquarellist] makes on the paper reveal the shape and movement more than these things [the objects] do themselves; in this way is born the miracle of transfiguration of the world into images, out of the simple ability of the artist to create them."

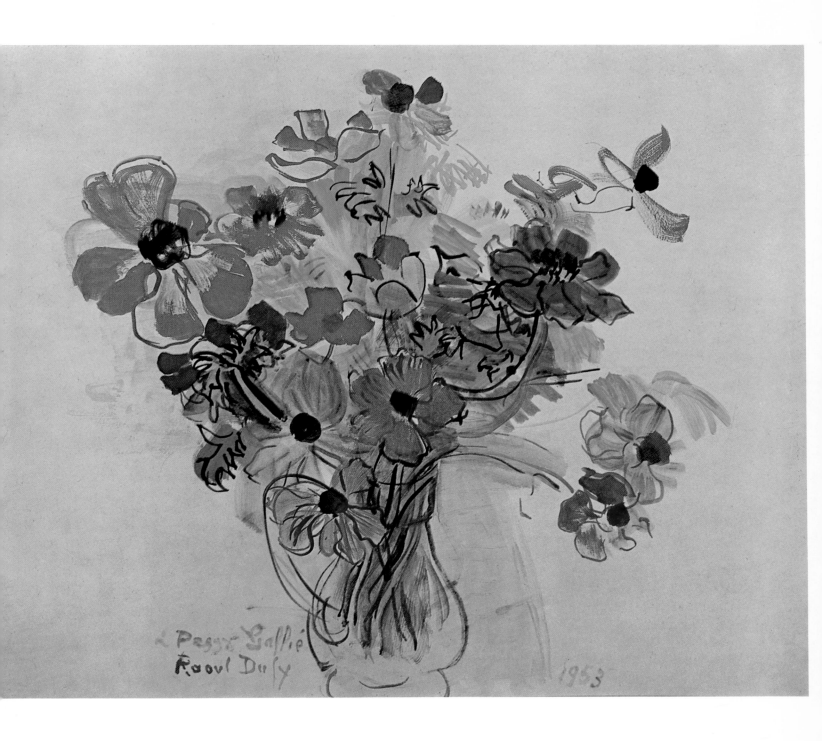

à Peggy Guggie
Raoul Dufy 1953